BOX

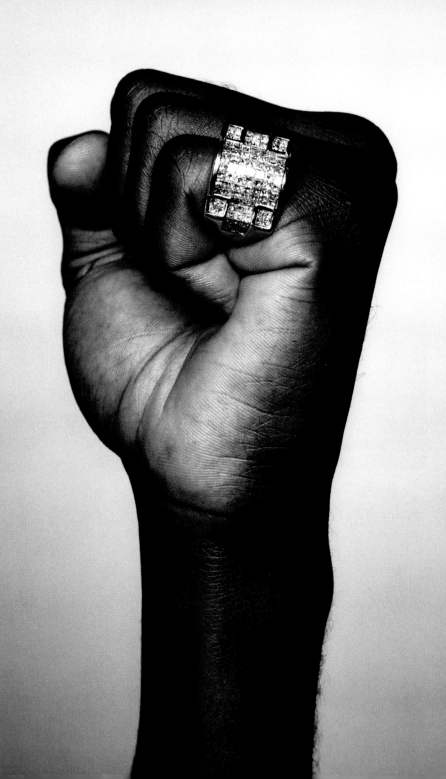

BOX

THE FACE OF BOXING

HOLGER KEIFEL

TEXT BY THOMAS HAUSER

CHRONICLE BOOKS

SAN FRANCISCO

"COURAGE IS HOW BAD YOU WANT IT."

THE FACE OF BOXING
THOMAS HAUSER

In 1926, George Gershwin wrote, "No one expected me to compose music. I just did it. What I have done is what was in me."

Similarly, no one expected me to become a writer; let alone a boxing writer. My first career was as a litigator at a large Wall Street law firm. I began writing in 1977 and, six years later, fell into boxing by chance. Since then, what I have done is what was in me.

Modern boxing has been contested largely in the United States, and recorded largely in the work of English-speaking writers. Times change. Boxing fans in America remain proud of what the sweet science once was. They are less proud of what it is today. But if boxing is no longer part of the American dream, it has moved to the forefront of the dream in other parts of the world. Fighters such as Manny Pacquiao, Ricky Hatton, and the Klitschko brothers have stirred passions around the globe.

My own love affair with boxing began in 1983. I'd just finished writing a novel about Beethoven and wanted to write a book about sports. Baseball had been my passion as a child, with football and basketball in the runner-up slots. I'd been a casual boxing fan, that's all.

But one can't just walk into Yankee Stadium and talk with the New York Yankees. Only a few writers have access to any of the athletes in the major professional sports; let alone the gods of games such as Tiger Woods, Roger Federer, and LeBron James.

Boxing, by contrast, is the most open of all sports. A fan can walk into virtually any gym in any city in the world and talk with the fighters who are training there. Empowered by that openness, I wrote a book about the sport and business of boxing entitled *The Black Lights*. Five years later, I was approached by Muhammad Ali and his wife, who asked if I'd be interested in authoring what we hoped would be the definitive Ali biography. *Muhammad Ali: His Life and Times* followed.

There were several more books. Then, in 1999, I began writing an Internet column about boxing. That brought me into the trenches in a way that I never would have thought possible.

Over the past decade, I've done my best to chronicle the contemporary boxing scene in all its glory and shame. I've written about the good and the bad; anonymous club fighters and champions; trainers, managers, promoters, television executives, and others who toil in boxing's vineyards.

One of the most gratifying things for me has been the number of fighters who've allowed me to spend the hours before a fight in their dressing room. I've often asked myself what it would mean for boxing history if someone had been in Joe Louis's dressing room, transcribing everything that happened before he fought Max Schmeling. Or in the dressing room with Jack Johnson, Jack Dempsey or Sugar Ray Robinson before a major fight.

That's what I've been privileged to do with Evander Holyfield, Roy Jones Jr., Manny Pacquiao, Bernard Hopkins, Jermain Taylor, Kelly Pavlik, Ricky Hatton, and dozens of others.

On occasion, I'm asked what I like most about writing about boxing.

My standard answer is, "The best thing about being a boxing writer is that you don't get hit." I should add that I don't really know what it's like to be in the ring as a fighter. I doubt that anyone does unless they've done it. I do know that it's something I could never do.

The fighters do the hard part. All I do is write about it from the safe side of the ropes.

Holger Keifel also fell into boxing by accident. We met in 2002, when he was assigned to photograph me for *Der Spiegel*. During the course of conversation, he told me he was interested in photographing what combat does to a fighter's face. That spring, I took him to a club-fight card in New York.

Since then, Holger has recorded more than three hundred subjects. Dozens of champions are in his portfolio, as are scores of boxing's "little people." On occasion, subjects come to his studio. But mostly he works quickly at press conferences, weigh-ins, and fights, using a Mamiya RZ camera with no computer gimmickry.

"Often, these guys are not in the mood for a picture," Keifel says. "Sometimes I have less than a minute, but most of them are pretty good about it. A lot of fighters start with the traditional pose, putting their fists up. I tell them, 'No, I'm not interested in that. I'm interested in your face.'"

We all age. As the years pass, our faces grow lined and bags form under our eyes. A fighter's face ages too, but in a different way. There's the broken nose at a young age. That's a given. Then comes scar tissue around the eyes, unnatural bumps, and the other telltale signs of a fighter's trade.

Keifel credits two photographers as having particular influence on his work. The first is August Sander (1876–1964). From the early 1920s until his death, Sander photographed thousands of German citizens from all walks of life in a project he envisioned as a comprehensive visual record of the German people. The Nazis confiscated the first publication of his work. Later, the majority of his negatives were destroyed by fire. Only 1,800 of the portrait negatives exist today. Holger notes, "You can tell a lot about those times by Sander's work."

The other, more formative influence, is Irving Penn (1917–2009). "I love Penn's work," Keifel says. "Sander photographed people in their environment. Penn takes his subjects out of their environment and captures their essence in their face. He photographs people in studio settings, even if it's just a simple backdrop, to remove every outside distraction from the image. Penn is a genius. He's on his own level; way above everyone else."

Keifel's boxing images are all in black and white. They are detailed and powerful. "I don't style," he says. "I document. I want an honest face."

The images in this book are photographic art in its purest form. Taken together, they constitute the most important collection of boxing portraits ever assembled. I'm proud to have my words joined with Holger's art.

BERNARD HOPKINS

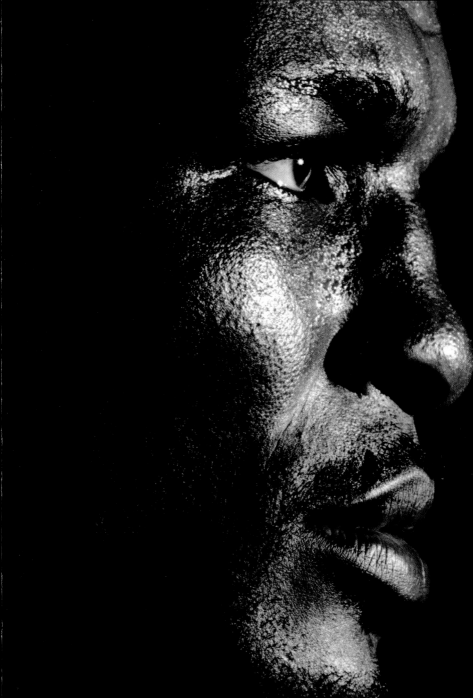

"I looked at Mike Tyson and I said to myself,

'THIS MAN

There ain't no sense in wishing him away. You got to fight him to become champion. But I knew I could break him."

EVANDER HOLYFIELD

IS GOOD'

"PEOPLE KEEP TELLING ME THAT BOXING IS A BRUTAL BUSINESS. DO THEY THINK I DON'T KNOW THAT?

I've been in the ring three times with Riddick Bowe; twice with Lennox Lewis. I beat Larry Holmes and George Foreman. I whupped Mike Tyson twice; had my ear chewed off and spat on the ground in front of me. I know this business better than anyone."

EVANDER HOLYFIELD

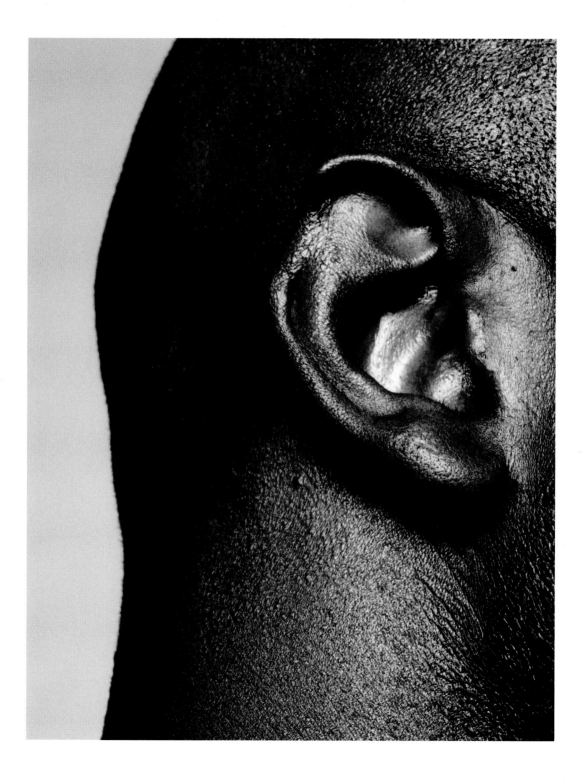

"The best decision I ever made was to retire from boxing.

I HATE THE SMELL OF A GYM.
I HATE THE BOXING GAME.

That guy I used to be; I don't know that guy anymore.
I don't have a connection with him anymore. I'm just not
that person anymore. I like the person I am now more
than I did. I don't like Iron Mike."

MIKE TYSON

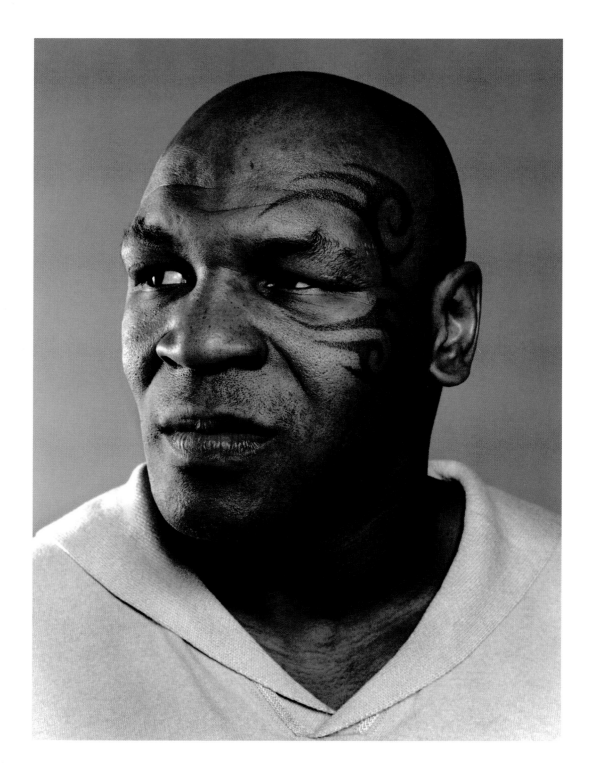

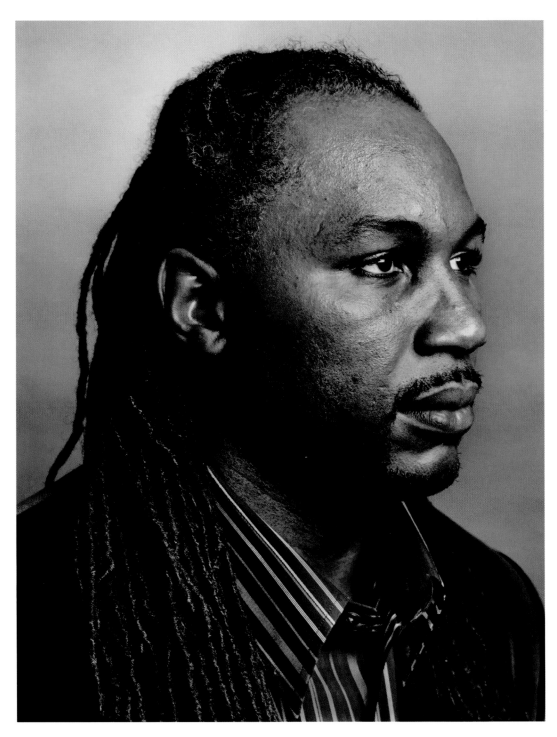

"Once you've been the undisputed heavyweight champion, there's no higher goal in boxing. And

NO MATTER HOW GOOD YOU ARE, YOU KNOW THAT SOMEDAY YOU'LL HAVE TO GIVE THE CHAMPIONSHIP UP.

So what you're really doing from that time on is boxing for money."

LENNOX LEWIS

"EVERY BOXER IS GOING TO GET HIT. EVERYONE IS GOING TO GET HURT SOMETIME DURING A FIGHT. IT'S JUST A QUESTION OF WHAT ARE YOU GOING TO DO WITH IT."

MIGUEL COTTO

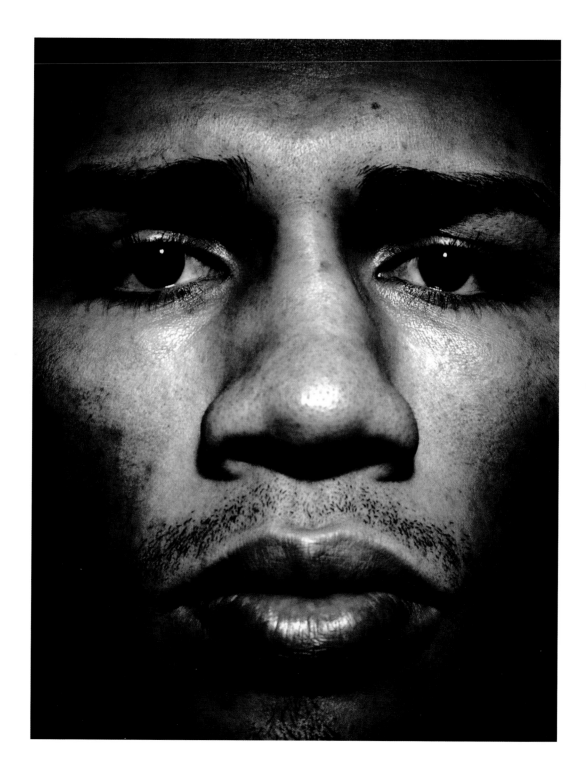

JAKE LAMOTTA

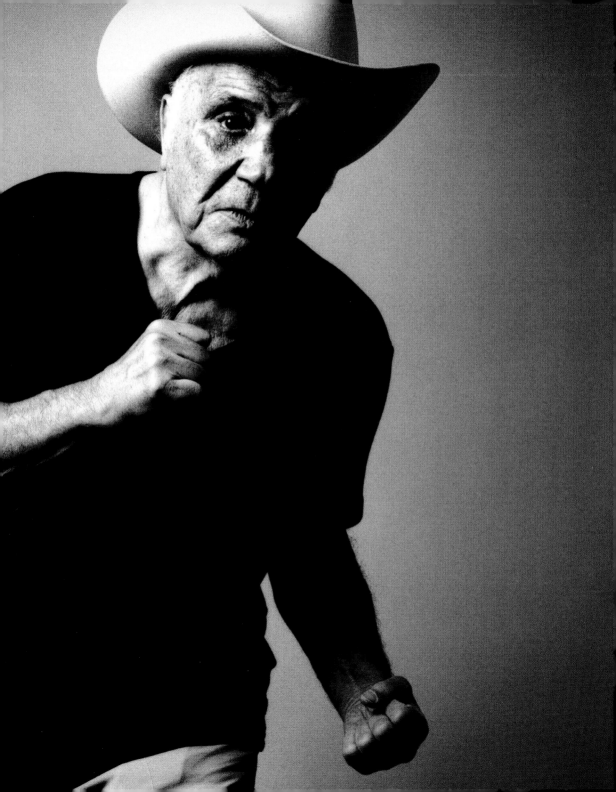

"THE FIRST THING YOU GOTTA DO IF YOU WANT TO BE A FIGHTER IS FIGHT."

JAKE LAMOTTA

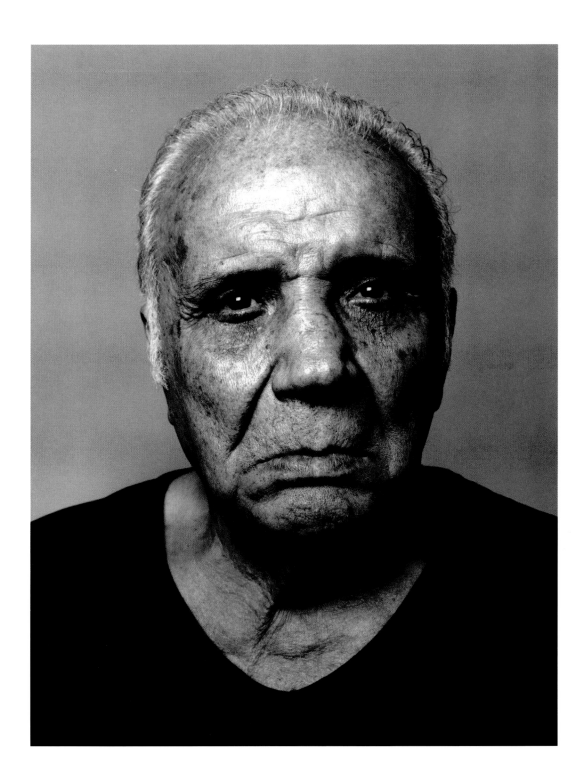

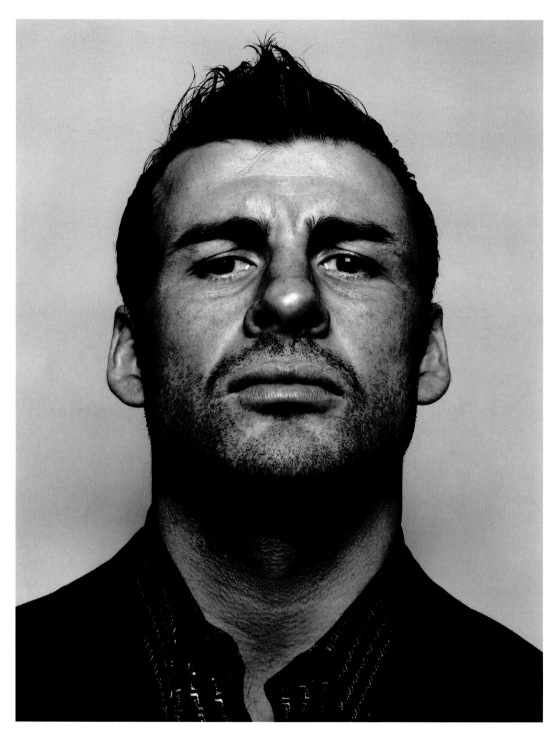

"I understand that in boxing the purpose is to do damage.
But I can only speak for myself and say honestly that

I HAVE NEVER WANTED TO SERIOUSLY HURT AN OPPONENT.

I'm not violent. It's just the nature of what I do. I know
the argument about intent. But I'm a fighter and I can
tell you what's in my mind. I have never set foot in a ring
with the express intention of inflicting serious harm on
my opponent."

JOE CALZAGHE

JOE CALZAGHE

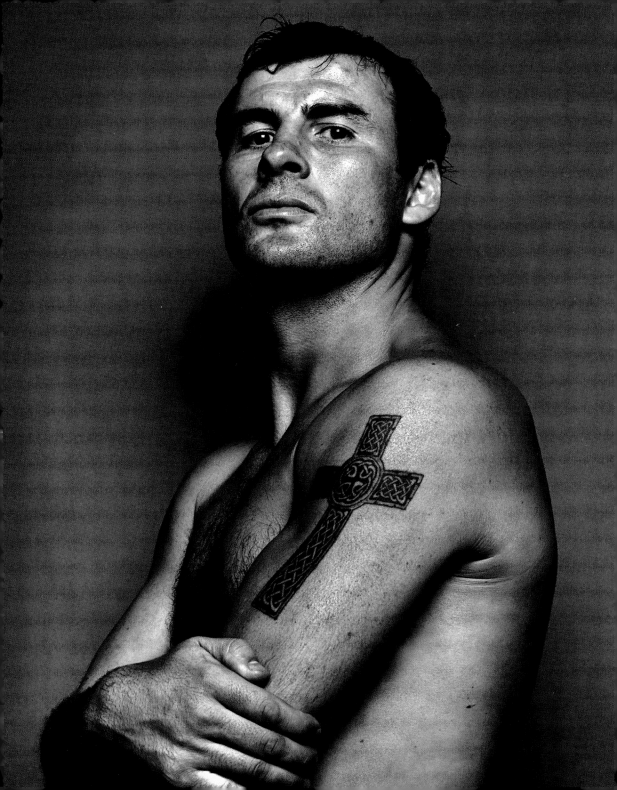

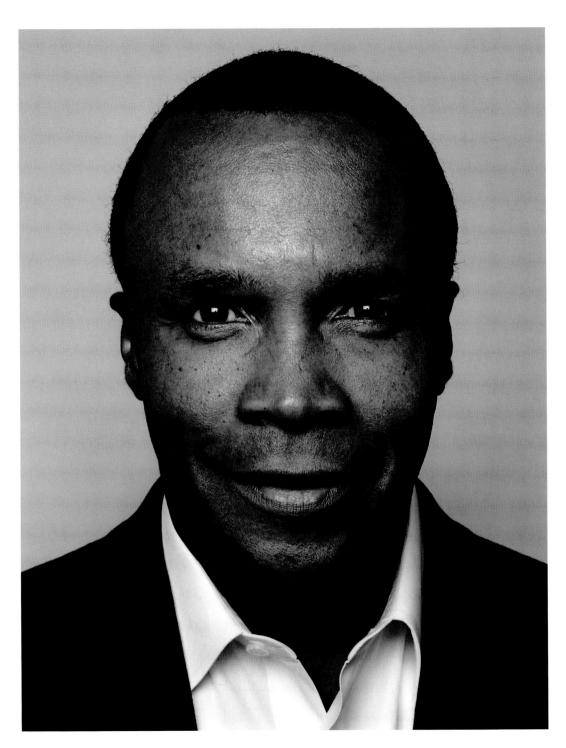

"THEY SAY THAT BOXING IS BRUTAL AND VIOLENT. BUT LOOK AT FOOTBALL. THEY DON'T TRY TO GET TO THE QUARTERBACK TO SHAKE HIS HAND."

SUGAR RAY LEONARD

"The boxing business is predicated on lies.

I AIN'T NO ANGEL . . .

but I ain't as bad as some people make me out to be."

DON KING

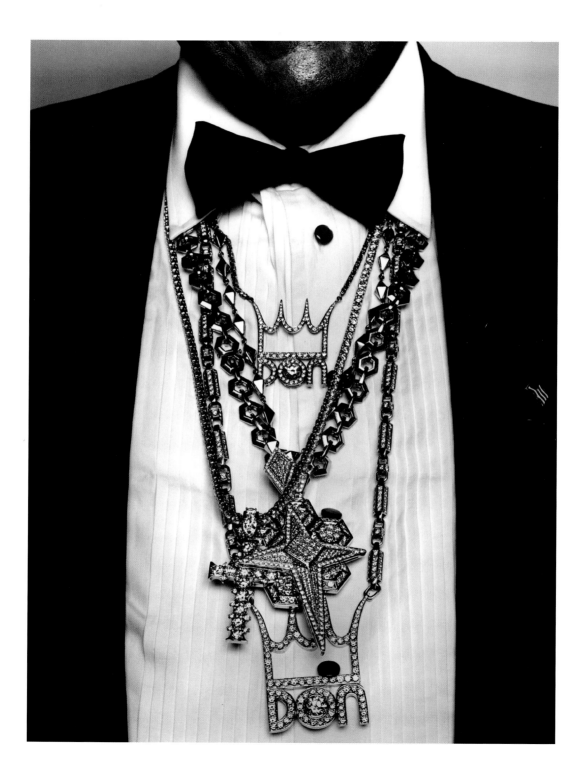

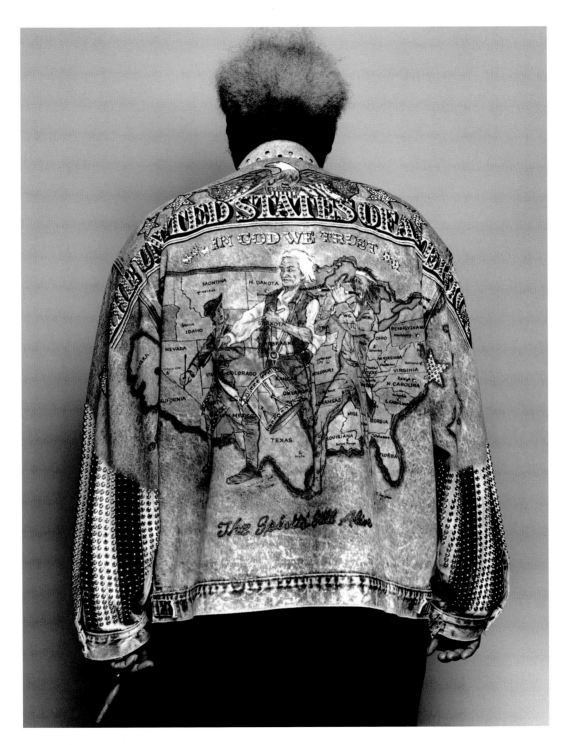

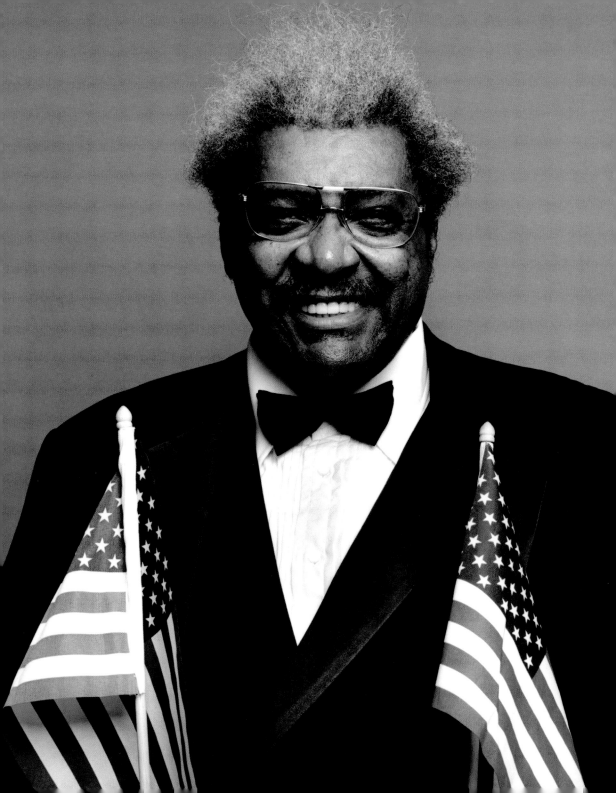

"One of the things that bothers me most is that

VERY FEW PEOPLE REALLY UNDERSTAND WHAT IT MEANS TO BE A FIGHTER.

I hate it when I hear someone say, 'That fighter doesn't have guts.' It really ticks me off. I don't care if you're a world champion six times over or a four-round fighter who just got knocked out in thirty seconds of your first professional fight; to step inside that ring, you have to have guts."

OSCAR DE LA HOYA

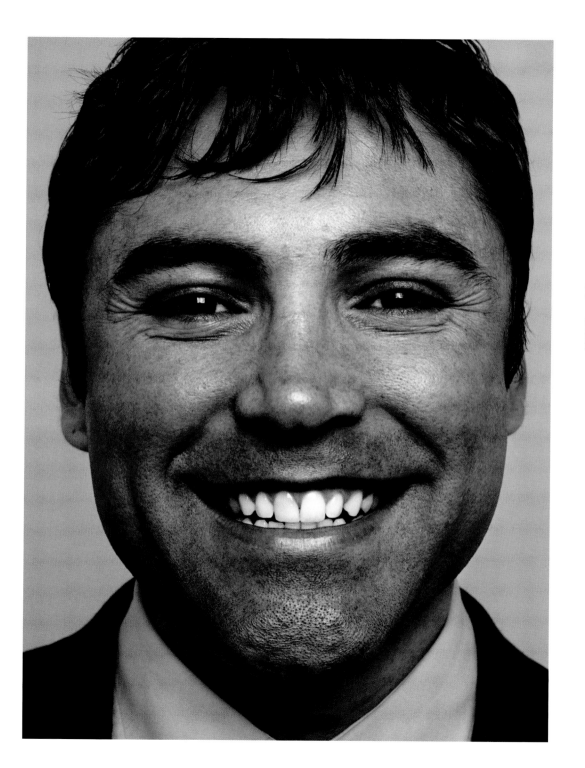

"THE GLORY IS THE ISSUE TO ME. MONEY COMES AND GOES, BUT A LEGACY STAYS FOREVER."

SHANE MOSLEY

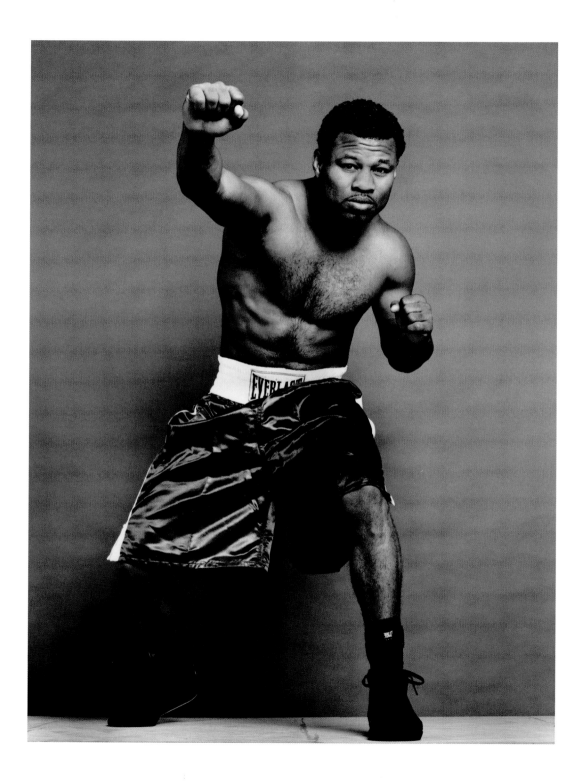

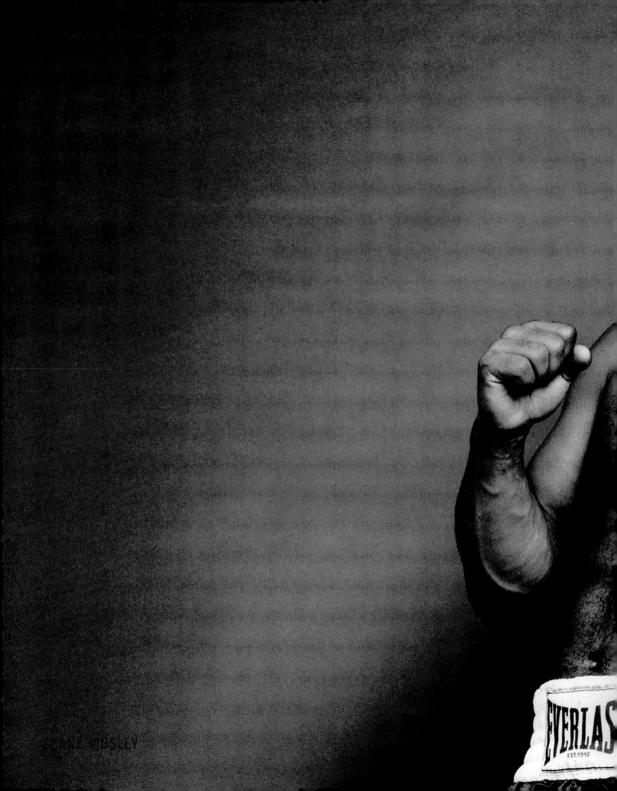

SHANE MOSLEY

EVERLAS
EST. 1910

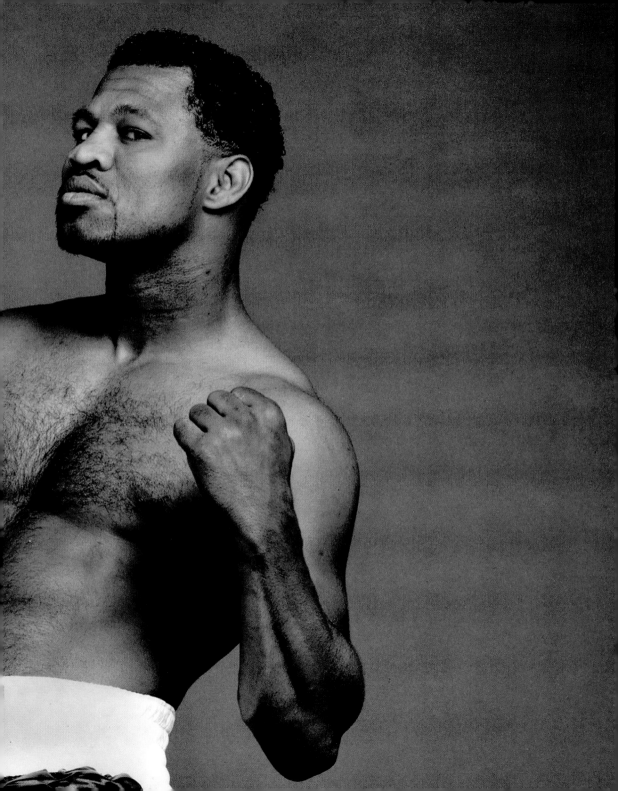

"LET'S GET READ

Overleaf, left to right; Brian Kenny, Harold Lederman, Rich Marotta, Bob Sheriden, Max Kellerman, Seth Abraham, Ross Greenburg, Ken Hershman, Jay Larkin, Mark Taffet, Steve Albert, Al Bernstein, Steve Farhood, Ron Borges, Bernard Fernandez, Bill Gallo, Jerry Izenberg, Tim Smith, Michael Katz, George Kimball, Dan Rafael, LeRoy Nieman, Jim Thomas, Tomas Mendoza, Lloyd Price

Y TO RUMBLE!"

MICHAEL BUFFER

Overleaf, left to right; Frank Cappucino, Joe Cortez, Eddie Cotton, Arthur Mercante Jr., Pete Santiago, Arthur Mercante Sr., Steve Smoger, Margaret Goodman, Jose Sulaiman, Jackie Tonawanda, Marc Ratner, Alan Hopper, Ricardo Jimenez, Ed Keenan, Lee Samuels, Flip Homansky, George Ward, Kevin Barry, Duane Ford, Cassius Green, Ron Scott Stevens, Johnny Bos, Arthur Curry, Jim Lampley, Felix Figeroa

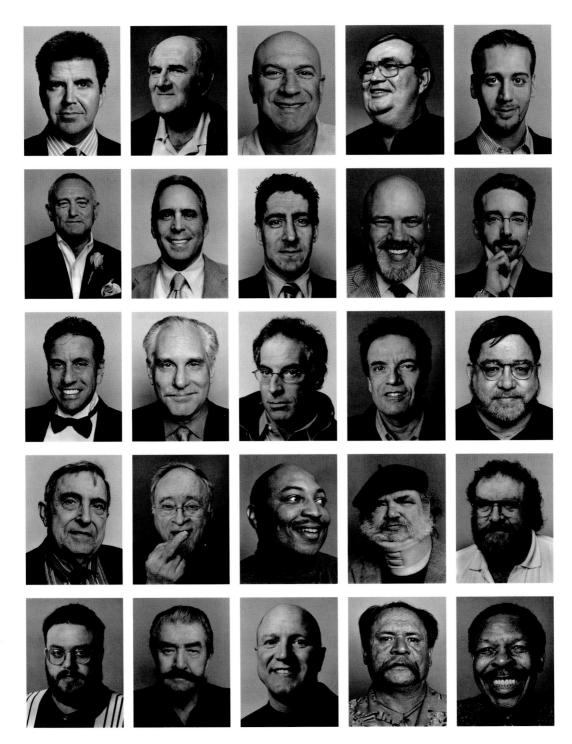

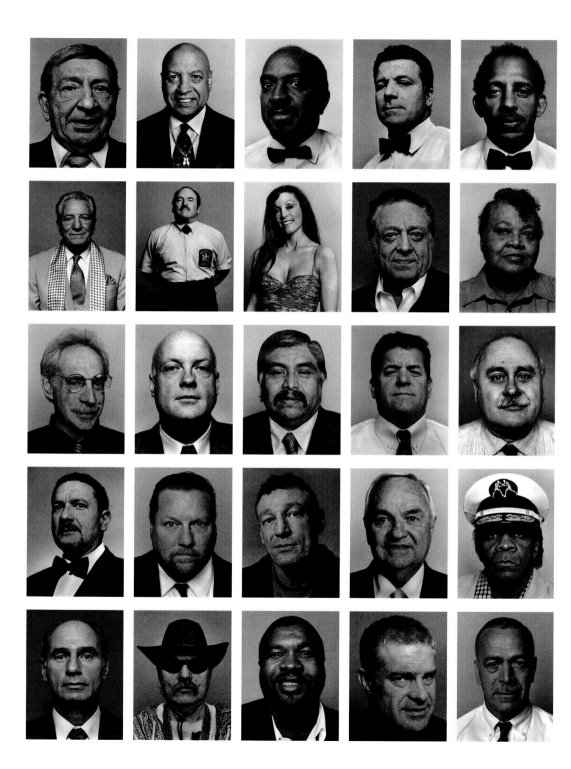

(on the origin of his trademark phrase: "Let's get ready to rumble!"): "I wanted something comparable to 'Gentlemen, start your engines' at the Indy 500; a hook that would excite people and put some energy into the arena. I tried 'man your battle stations' and 'batten down the hatches' and 'fasten your seat belts,' but none of them worked. Then I remembered Muhammad Ali saying,

'FLOAT LIKE A BUTTERFLY, STING LIKE A BEE; RUMBLE, YOUNG MAN, RUMBLE.'

And when Sal Marchiano was the blow-by-blow commentator for ESPN, he'd say, 'We're ready to rumble.' So I took those ideas and fine-tuned them."

MICHAEL BUFFER

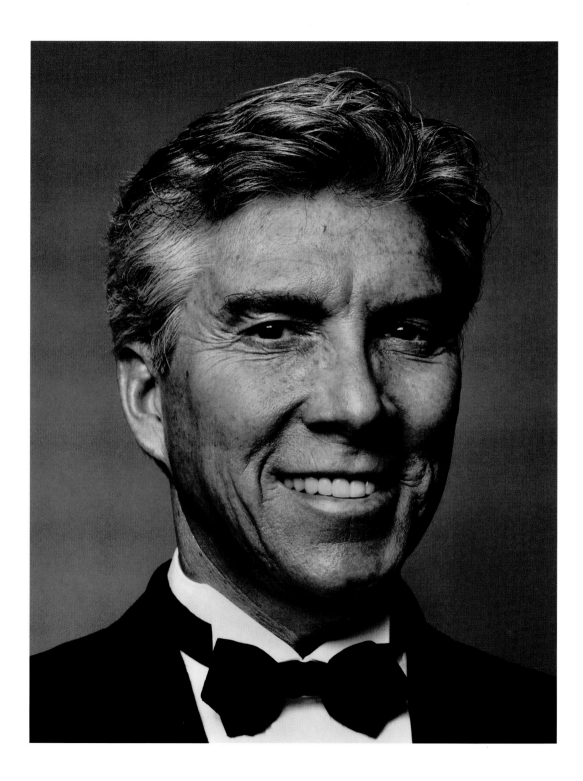

"THAT NIGHT AT MADISON SQUARE GARDEN; FIFTEENTH ROUND WHEN I PUT ALI DOWN. I STOOD WHERE NO ONE ELSE EVER STOOD."

JOE FRAZIER

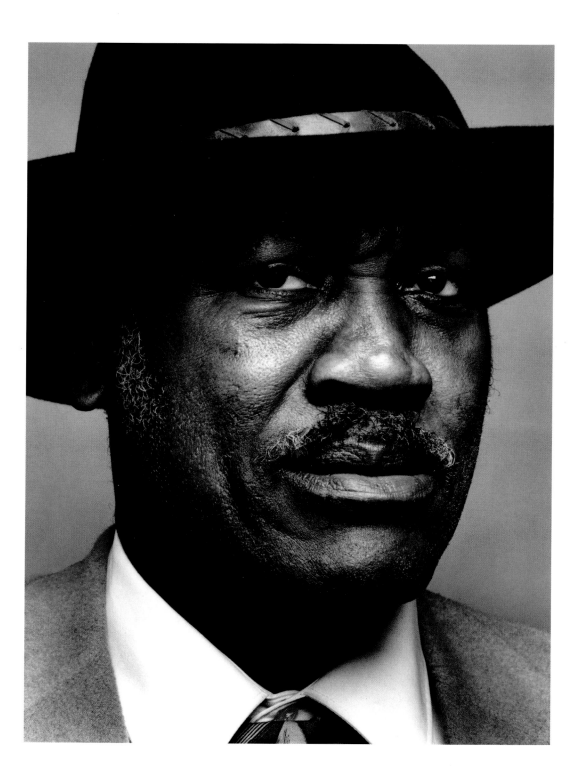

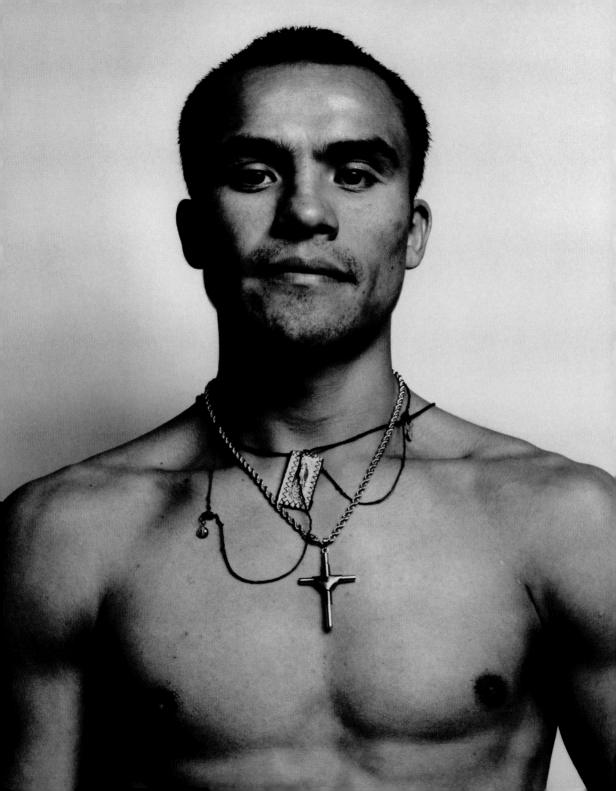

JUAN MANUEL MARQUEZ

"I used to take three punches to land one because I didn't know how to do it any other way. After a while, you find yourself making the right moves to slip punches or to feint a man off balance. You find yourself recognizing the other man's feints and countering effectively. It's hard to explain because

WHAT YOU LEARN IS IN YOUR MUSCLES AND YOUR REFLEXES AS MUCH AS IN YOUR MIND."

CARMEN BASILIO

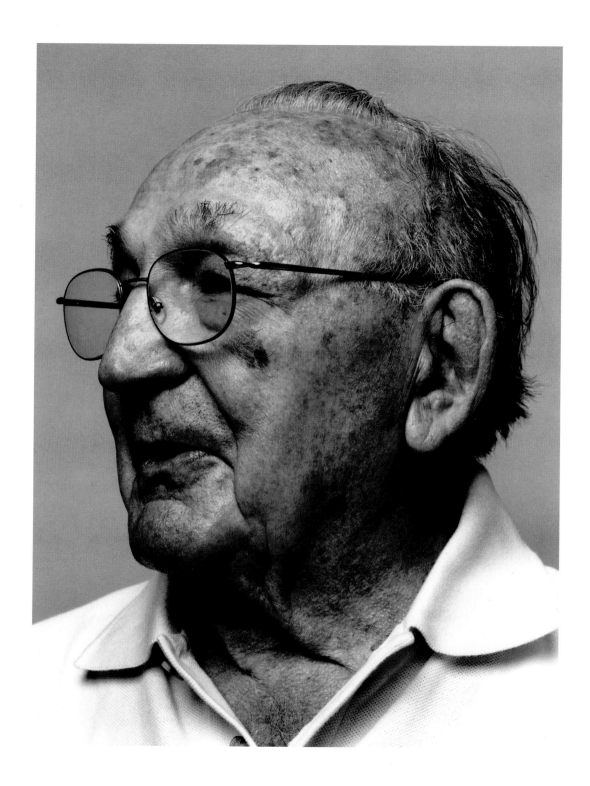

"I AM NOT A MACHINE; I AM NOT A PIECE OF MEAT;

I am not a circus show. I am a normal human being. I have human feelings. I have a beautiful family. I have many friends. I like good music, classical music. I read books. People sometimes do not treat me like a human being because of my size. They make a sensation. I try to not take it personally because they do not know me as a person, but there are times when it hurts me inside."

NIKOLAY VALUEV

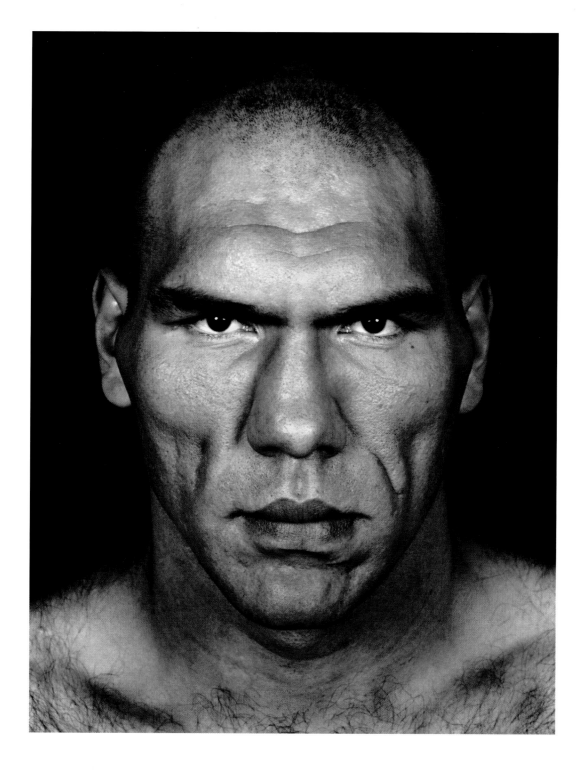

NIKOLAY VALUEV

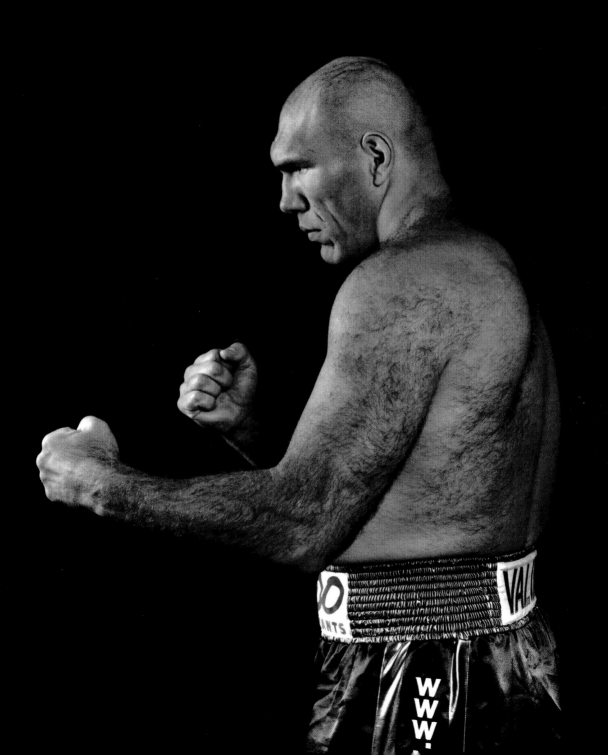

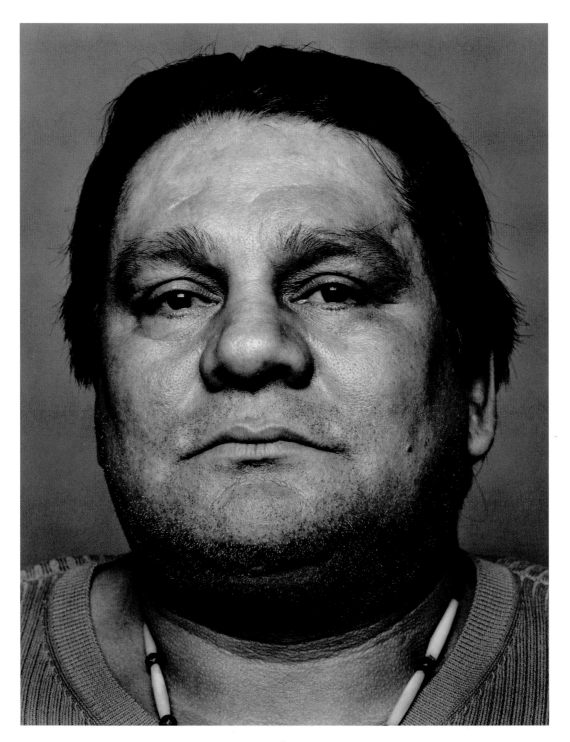

"A fighter needs a mean streak to be successful.

IF YOU'RE GOOD, THAT'S GOOD. BUT IF YOU'RE GOOD AND MEAN, THAT'S BETTER. IN THE RING, YOU NEED CRUELTY TO BE GREAT."

ROBERTO DURAN

"People watch me because I'm an exciting fighter. But I think they watch me too because they look on me as a mate. I get a huge rush when fans say how much they love me, but I don't expect people to roll out a red carpet when I walk down the street. I'm just a normal kid doing very well at what he does. My life is my family and friends and boxing. I like my food. I'll go to the pub for a few pints and to throw darts. There's two things you'll always get from me:

AN HONEST EFFORT IN THE RING AND AN HONEST ANSWER OUT OF IT."

RICKY HATTON

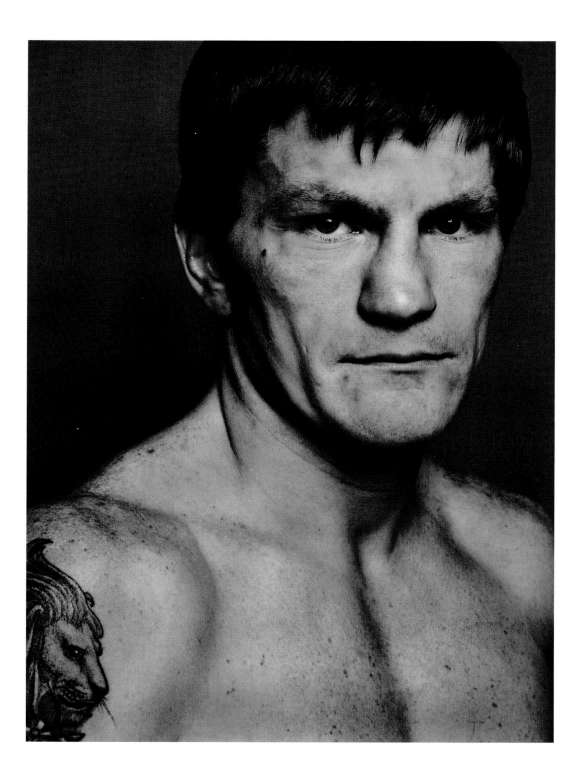

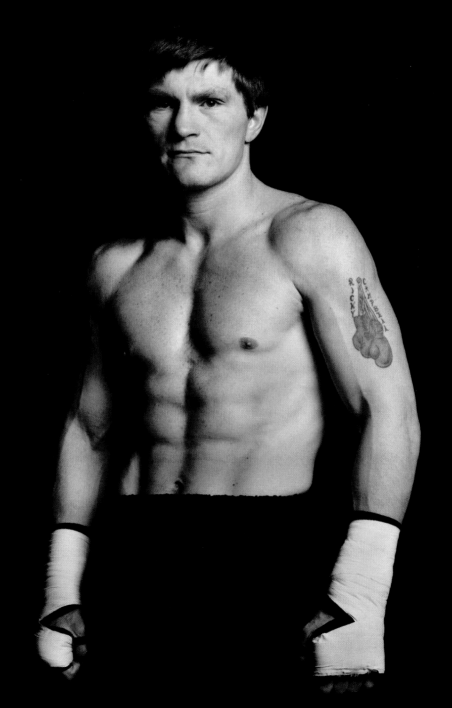

"I'm in the fight business. While the fight's going on,

THE FIGHT BUSINESS IS NOT ABOUT, 'ARE YOU OK? ARE YOU ALL RIGHT? DID I HIT YOU TOO HARD?

Oh, I'm sorry I hit you in the ribs.' It's legal to hit a guy in the Adam's apple. A shoulder can be hit. Trust me, whatever limb you give me, I'm punching it. I'm going to fight you for twelve rounds. If you beat me, it won't be by luck. I'll do anything to win."

BERNARD HOPKINS

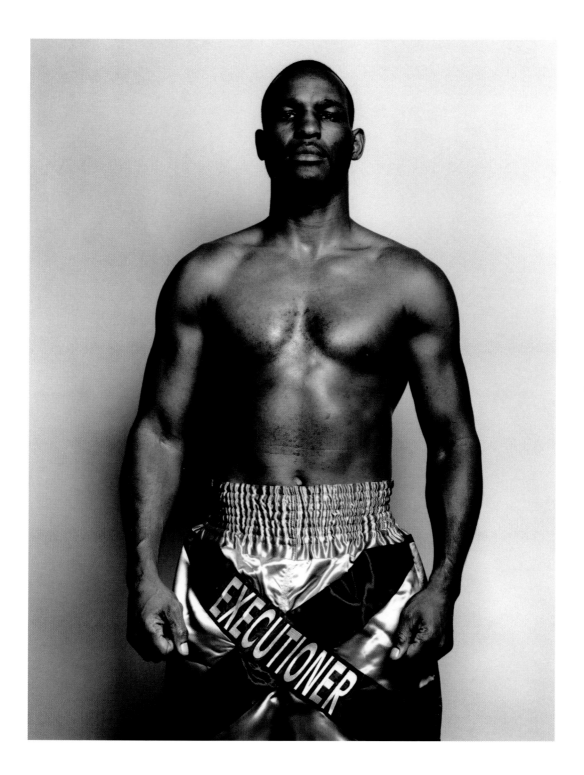

"Anyone who thinks they can make

KLITSCHKO V

S KLITSCHKO,

tell them to negotiate with our mother."

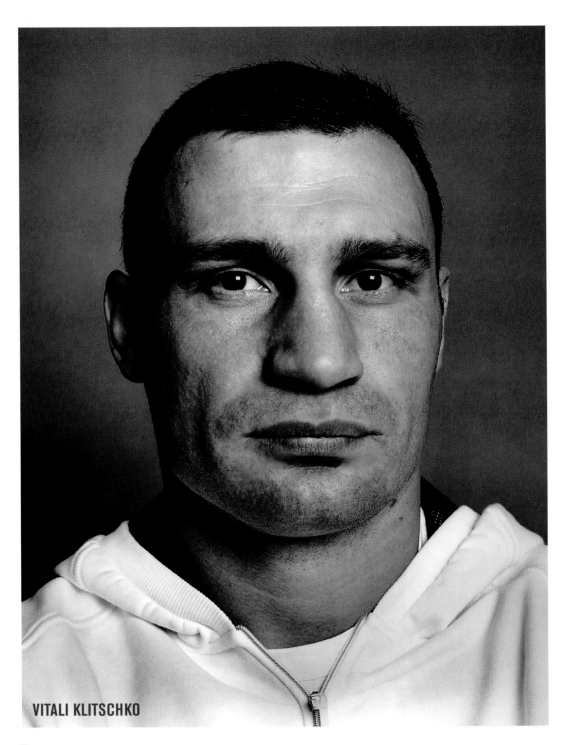

VITALI KLITSCHKO

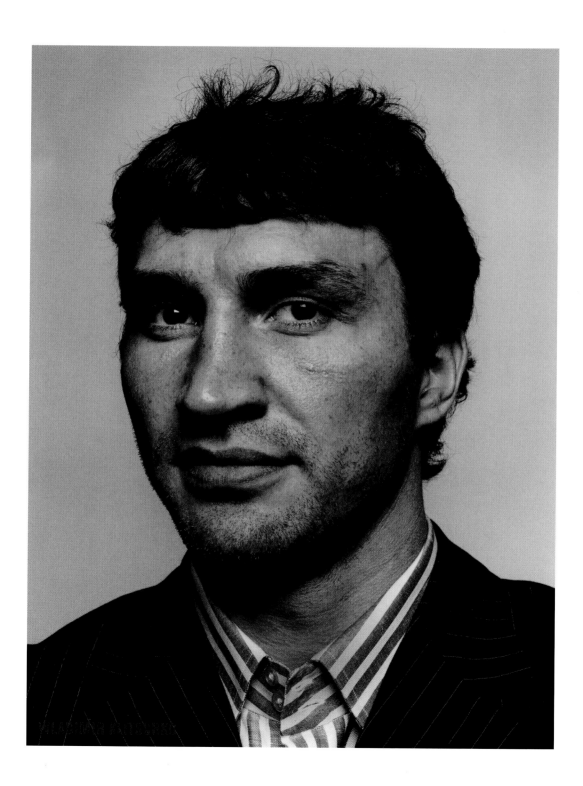

"I'M GOD'S GAME ROOSTER. GOD SENDS ME OUT TO FIGHT."

ROY JONES JR.

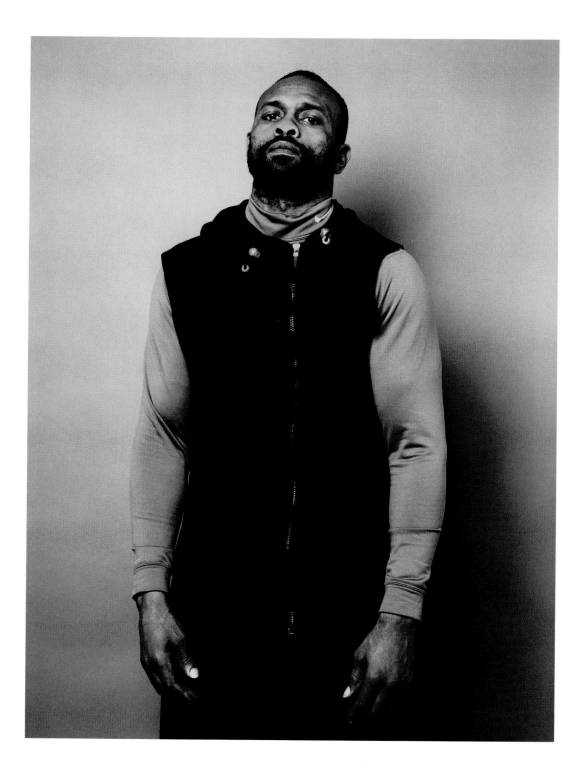

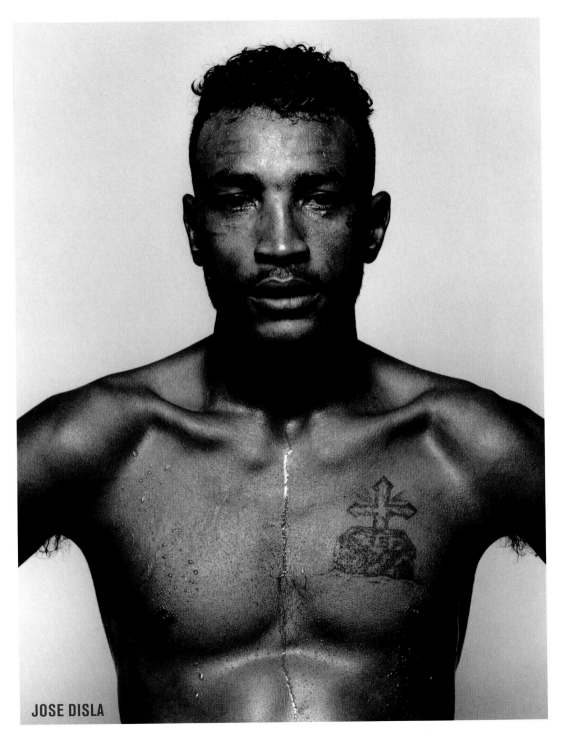

JOSE DISLA

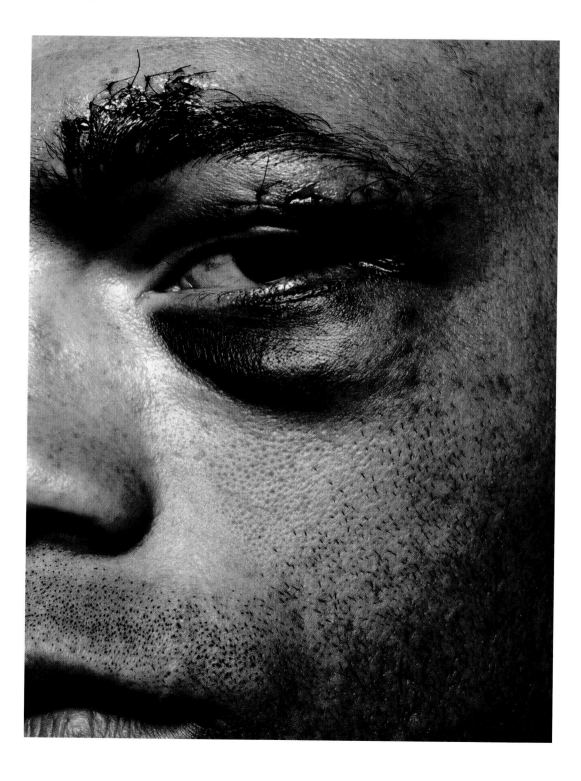

"The moment of truth for me came when I signed the contract for a fight. From that time on, I was afraid all the time. The closer a fight got, the more nervous I was. I didn't talk about it; I kept it in. But it was always on my mind. In the dressing room before a fight, I'd tell myself that it was going to be just like going out to the gym to spar with people watching. Then, walking to the ring, I'd tell myself that

I MUST BE CRAZY TO DO WHAT I WAS DOING;

but I was the one who wanted to do it, so go do what you got to do. And I'd say a prayer: 'God, don't let this man hurt me and don't let me hurt him.'"

LARRY HOLMES

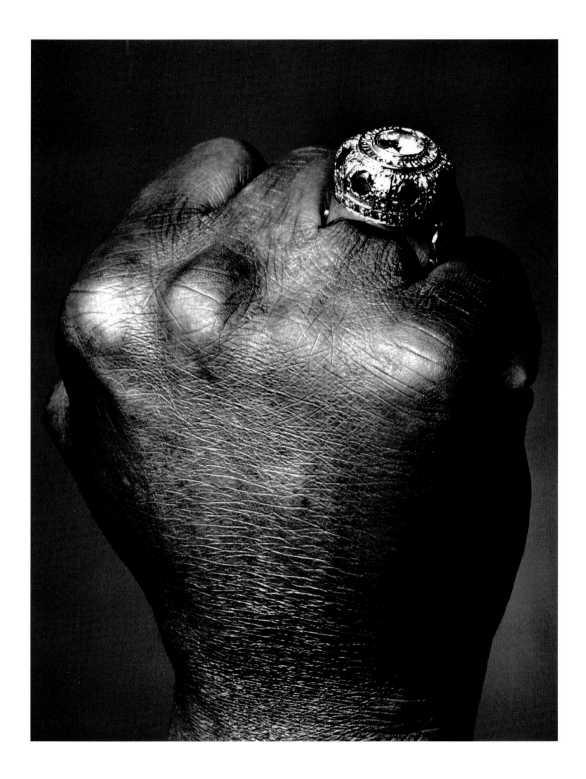

"I'm the master. I know all about jewelry.

PEOPLE SAY I'M COCKY AND ARROGANT, BUT I SAY I'M CONFIDENT AND SLICK.

And my lifestyle is flashy. I like flashy jewelry, flashy cars; that's me. There's never too many diamonds."

FLOYD MAYWEATHER JR.

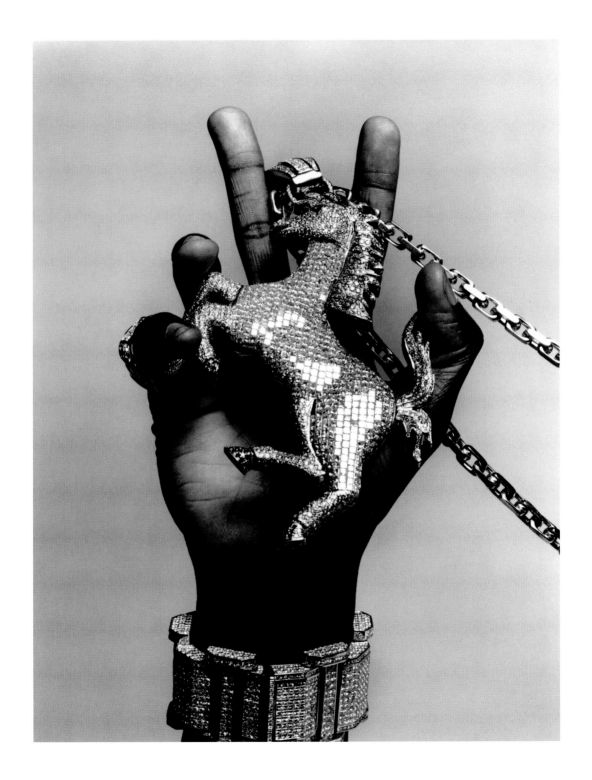

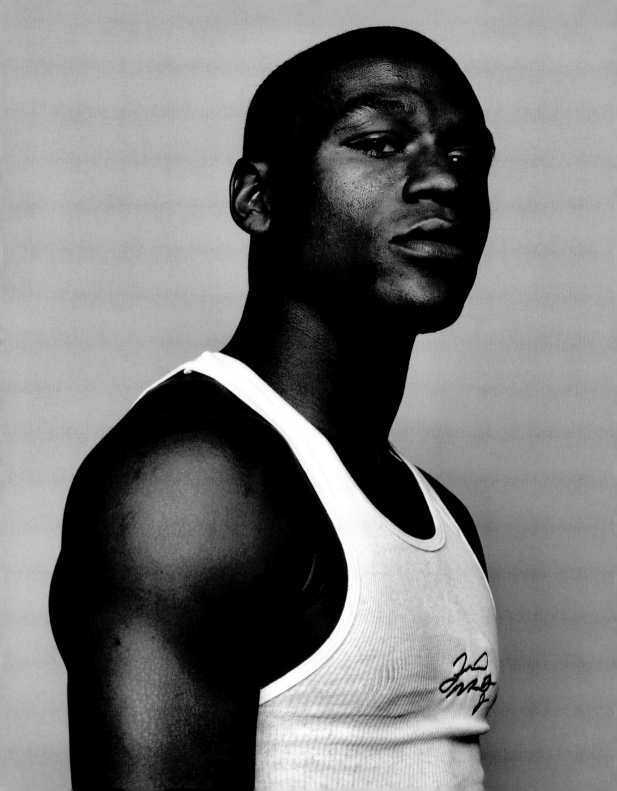

FLOYD MAYWEATHER JR.

"Most of the writers are fucked up and messed up. They don't feel good about themselves, so they take it out on someone else. They write shit about you. And then, when they need you for a story, they're all smiles and excuses and,

'OH, JAMES, I DIDN'T MEAN IT THAT WAY.' YOU DIDN'T MEAN IT THAT WAY? KISS MY ASS, MOTHERFUCKER.

What they write don't hurt me, but it pisses me off. You got guys 300 pounds, writing, 'James Toney is out of shape; James Toney has a belly.' Look in the mirror, you fat motherfucker."

JAMES TONEY

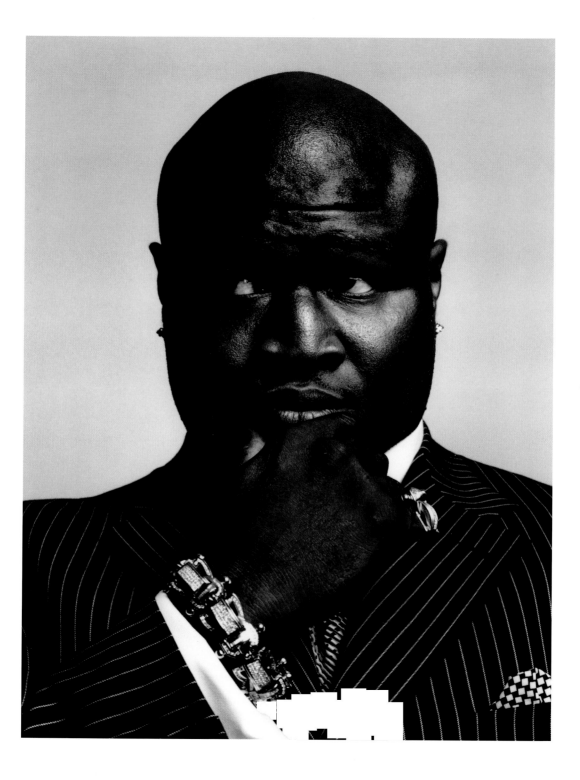

[on the first Gatti-Ward fight]: "I was very drained, as tired as I've ever been. The night after the fight, I sat down and watched the tape. That's when I knew it was something special. That's also when I said to myself,

"THESE TWO GU

YS ARE NUTS.”

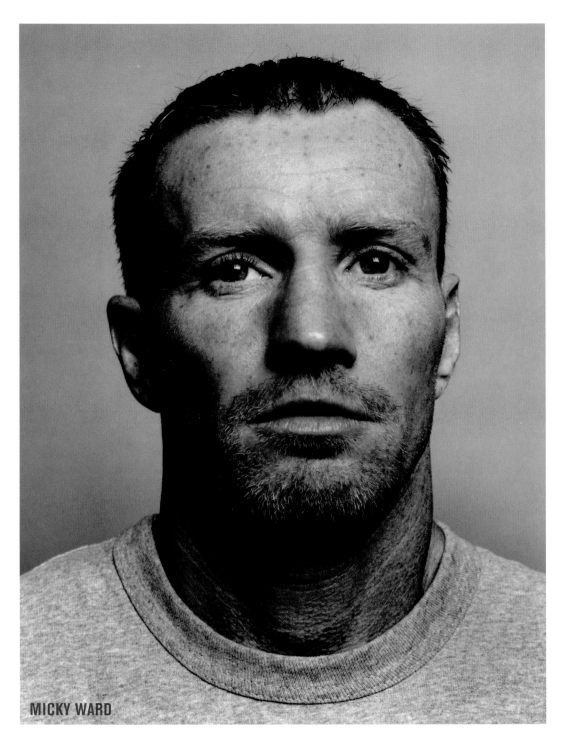

MICKY WARD

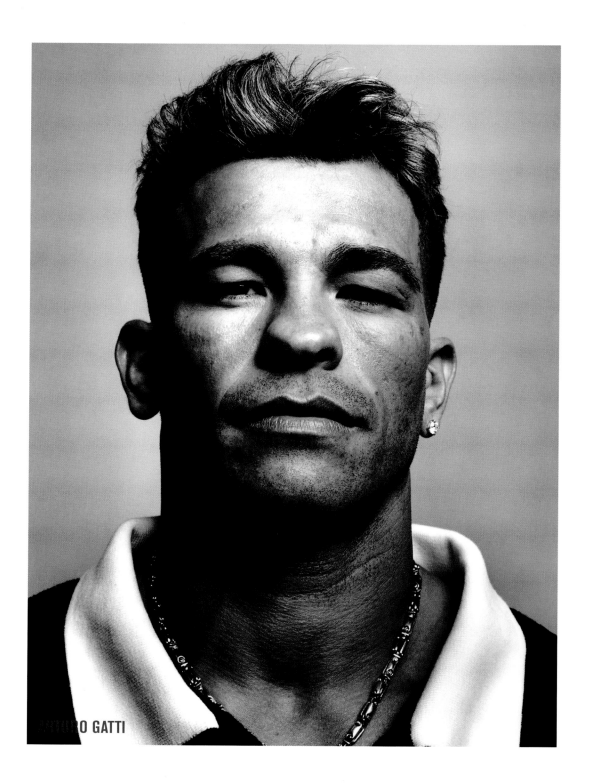

ARTURO GATTI

"In Youngstown,

WHEN YOU'RE ON TOP, YOU'RE ON TOP.

But when you let them down, you're the worst person in town. It's funny how that works. You don't want to become the bad guy in the city for failing at something. But at the same time, it's pretty neat to be that guy."

KELLY PAVLIK

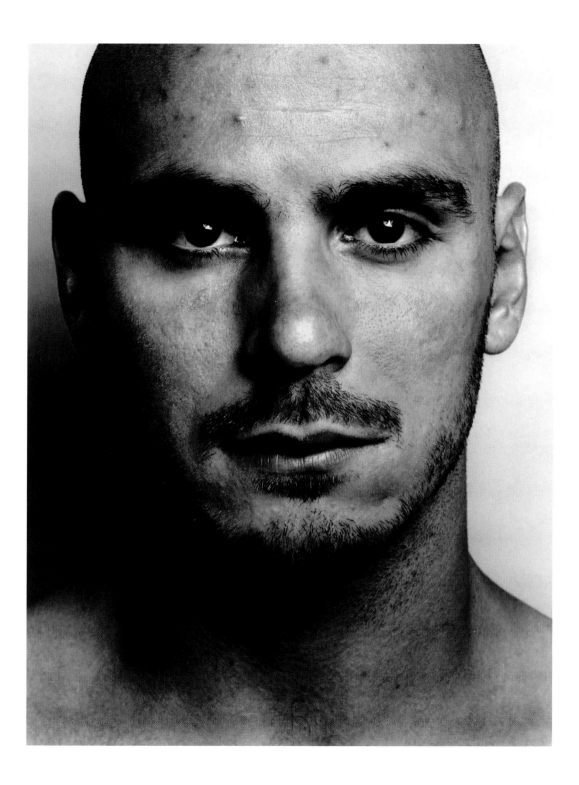

"I DON'T WANT TO BE REMEMBERED AS THE MAN WHO BROKE MUHAMMAD ALI'S JAW.

I just want to be remembered as a man who fought three close competitive fights with him and became his friend when the fighting was over."

KEN NORTON

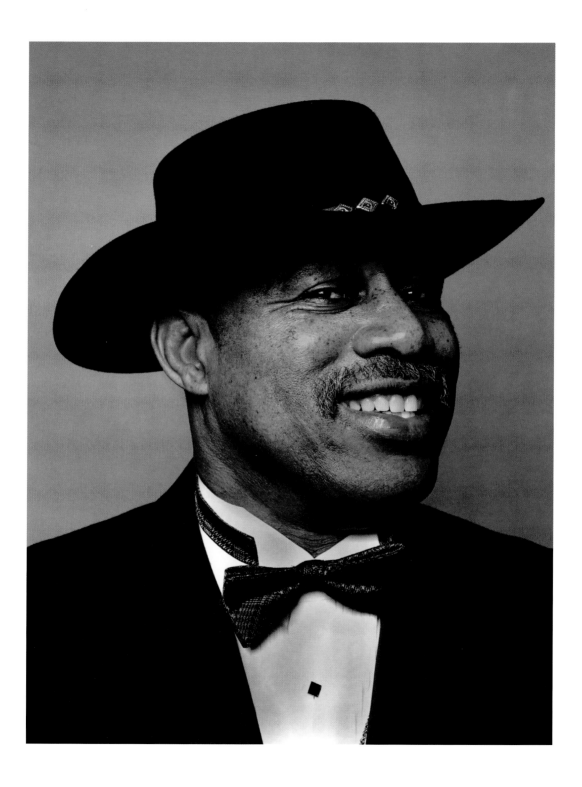

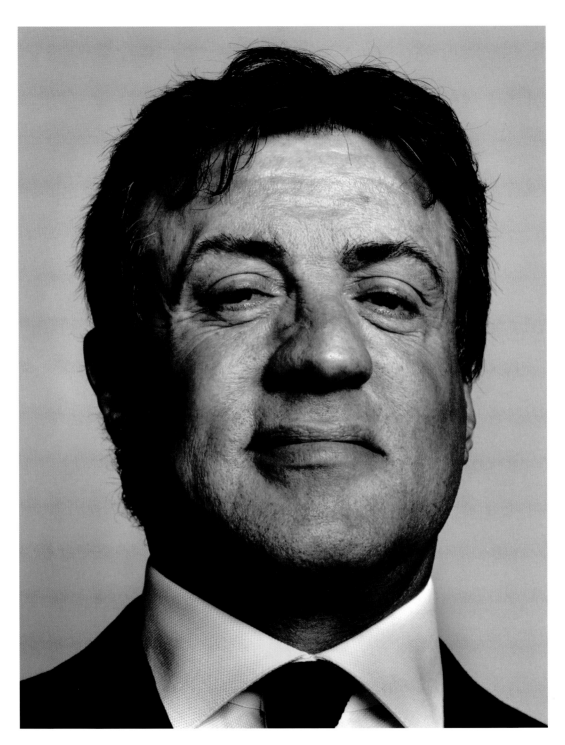

"I never went to a fight before I wrote *Rocky*. I was always either doing other things or was too poor to go. The first fight I went to was Larry Holmes against Ken Norton at Caesars in Las Vegas. What a great fight! And to be honest, if I'd seen that fight before writing *Rocky*, the movie might have been a little different because one of the things that struck me about Holmes-Norton was the audience participation. At Holmes-Norton,

I REALIZED THAT THE CROWD IS A CHARACTER IN ITSELF."

SYLVESTER STALLONE

"I HAVE TO FIGHT. FIGHTING IS MY DESTINY."

TOMASZ ADAMEK

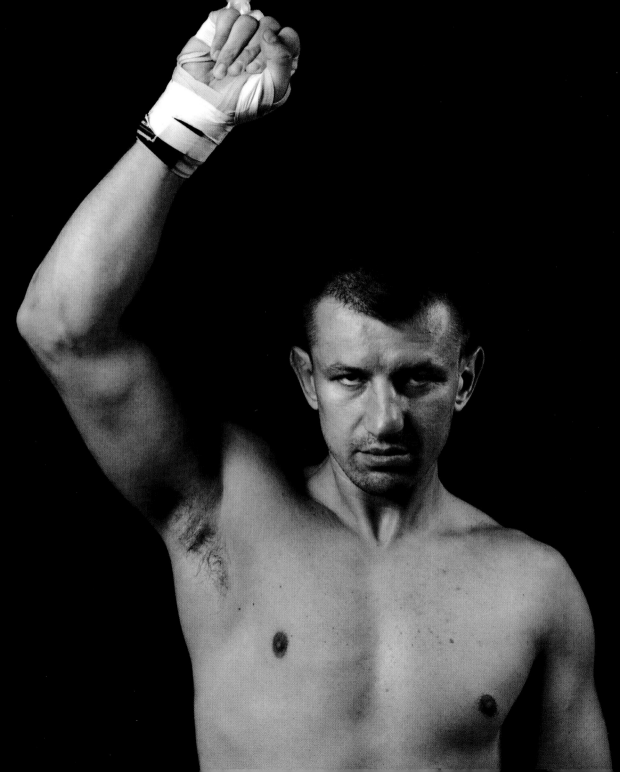

"I LIKE BOXING PEOPLE, AND I LIKE BEING ONE OF THEM."

LARRY MERCHANT

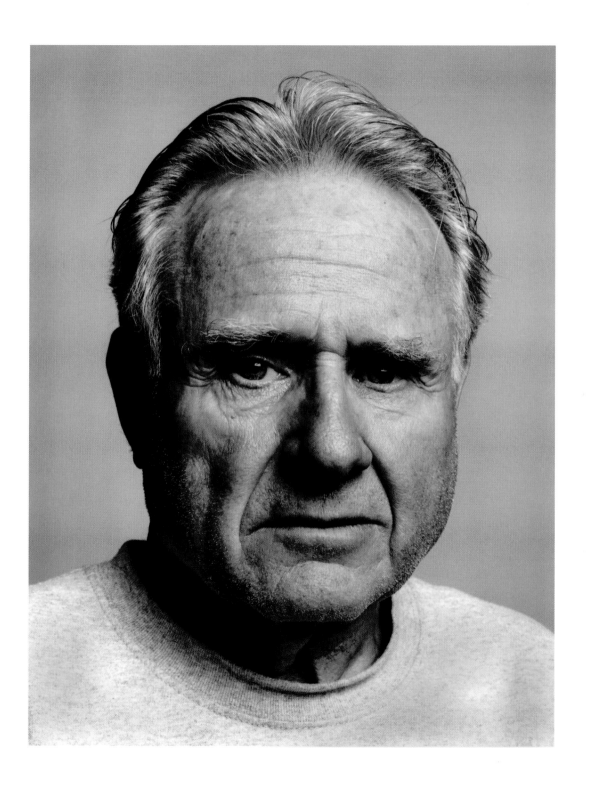

"BOXERS AR

Overleaf, left to right; Iran Barkley, Wayne Braithwaite, Mark Breland, Jermain Taylor, Tim Witherspoon, Curtis Cokes, John Stracey, Ruben Olivares, Daniel Zaragoza

E A FAMILY.

We know things about boxing that other people don't. We understand that, even when we win, we lose a little of ourselves every time we get in the ring."

LENNOX LEWIS

Overleaf, left to right; Cory Spinks, Felix Sturm, Brian Viloria, Lamon Brewster, Al Cole, Felix Trinidad, Billy Costello, Louis Del Valle, Diego Corrales

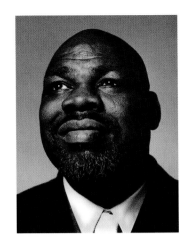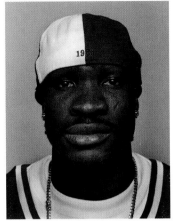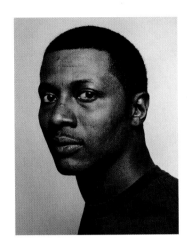
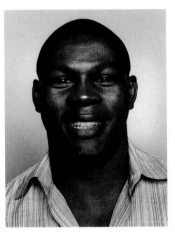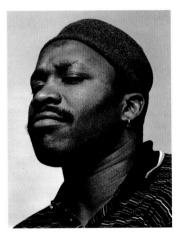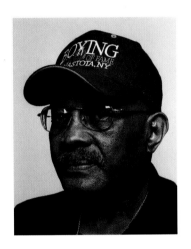
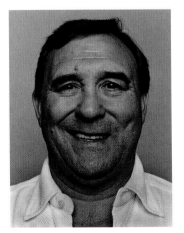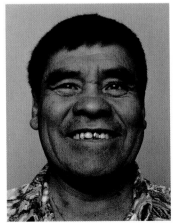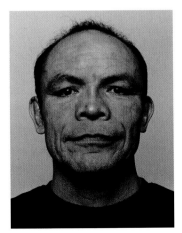

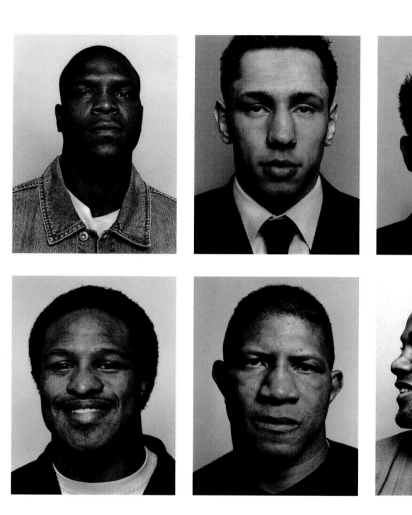
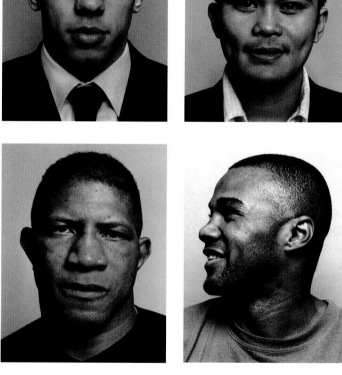
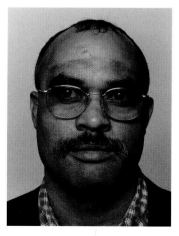
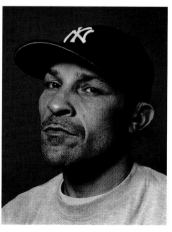
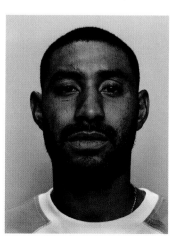

"There is bad news all the time in my country. There is not enough food. We have typhoons. There is corruption in the government and too much crime. So many people are suffering and have no hope. Then I bring them good news and they are happy. I know that millions of people are praying for me, and that gives me strength.

MY FIGHT IS NOT ONLY FOR ME BUT FOR MY COUNTRY."

MANNY PACQUIAO

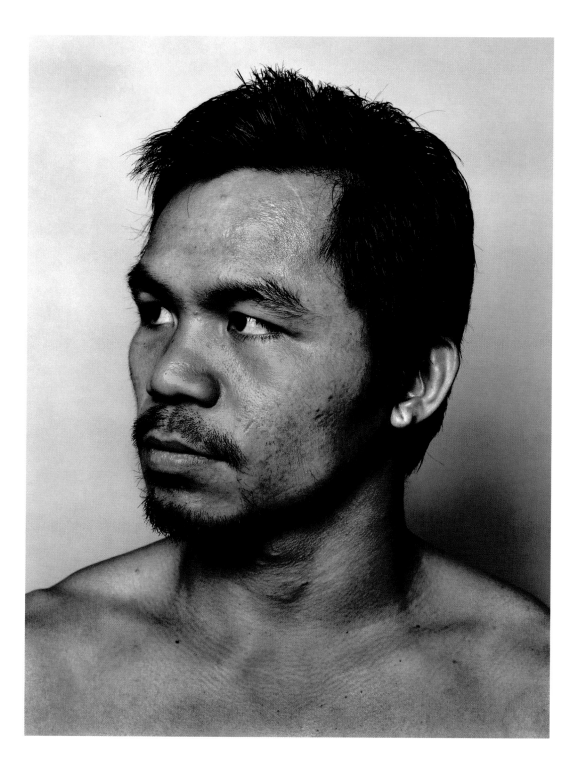

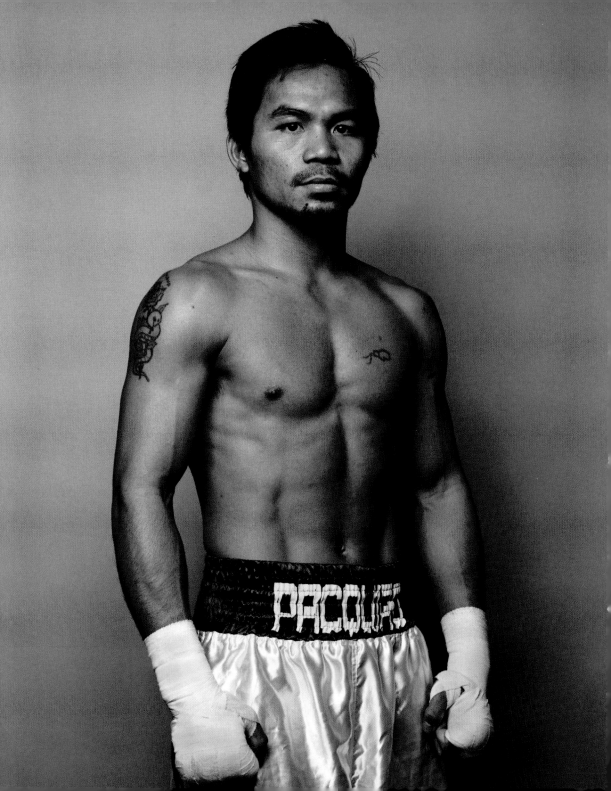

MANNY PACQUIAO

"I KNOW A GOOD THING WHEN I SEE IT.

Fist-fighting is a good thing. Every great fight is a rare nugget. If our civilization is indeed declining and if it finally falls, it will not be because Joe Louis clobbered Max Schmeling or took the measure of Billy Conn."

BUDD SCHULBERG

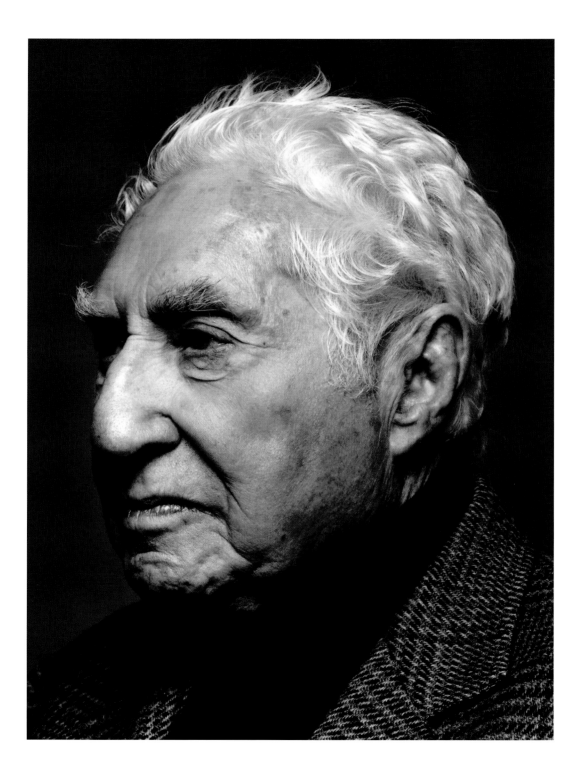

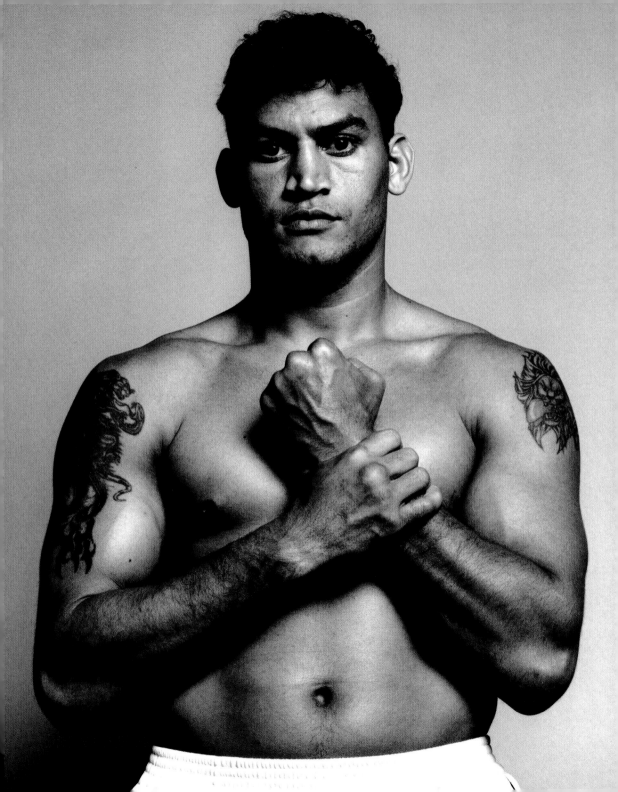

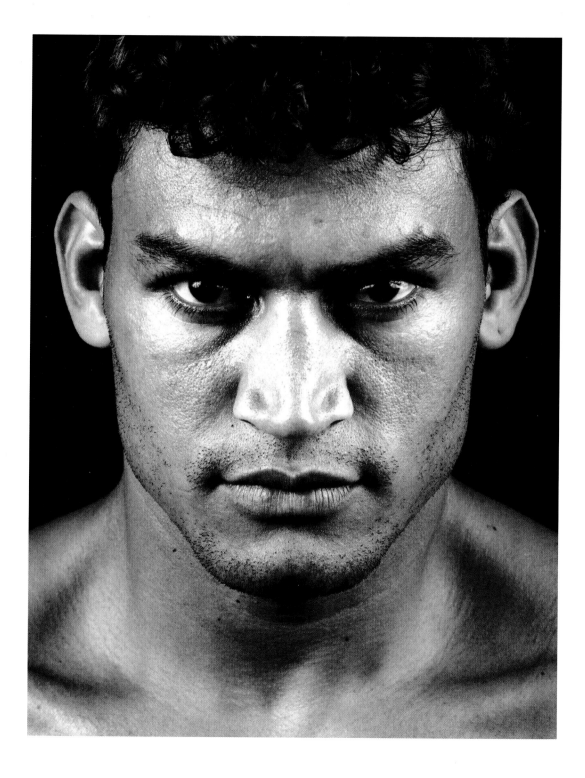

"SOMEONE COUNTED THEM ALL UP AND TOLD ME THAT I HAD 345 STITCHES IN MY FACE.

That's a record or something."

VITO ANTUOFERMO

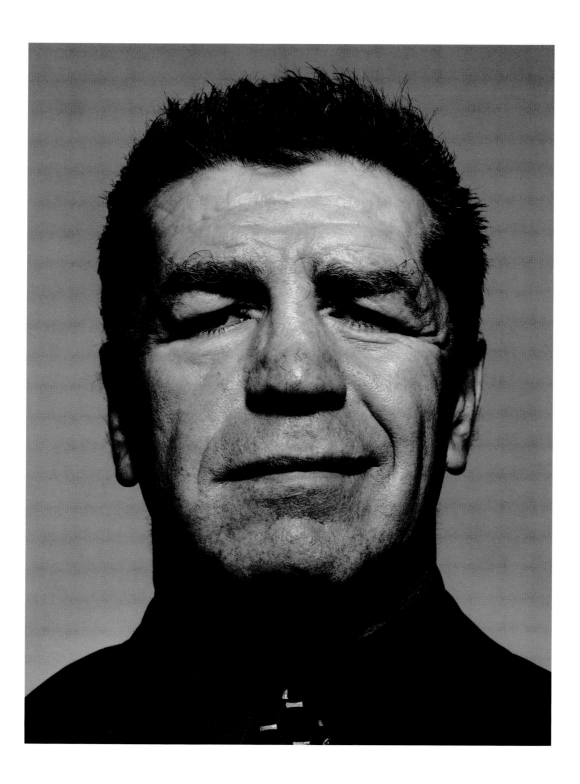

"HITTING OTHER

Overleaf, left to right; Louis Azille, Charles Lee Brown, Vinnie Cidone, Randall Cobb, Jaidon Codrington, Howard Davis, Tony DeMarco, Andre Dirrell, Chuck Wepner, Mitch Green, Dominick Guinn, Eugene Hairston, Vinny Maddalone, Peter Manfredo Jr., Jameel McCline, Joe Mesi

PEOPLE IS EASY.

Getting hit in the face is hard. Most athletes believe they won't get hurt in competition. Boxers know they will."

RANDY NEUMANN

Overleaf, left to right; Carlos Nascimento, Randy Neumann, Carlos Ortiz, Kassim Ouma, Alvaro Perez, Lou Savarese, Keene Simmons, Bowie Tupou, Roger Mayweather, Floyd Mayweather Sr., Michael Grant, Billy Backus, Danny Lopez, Jose Torres, Aaron Pryor, Juan Diaz

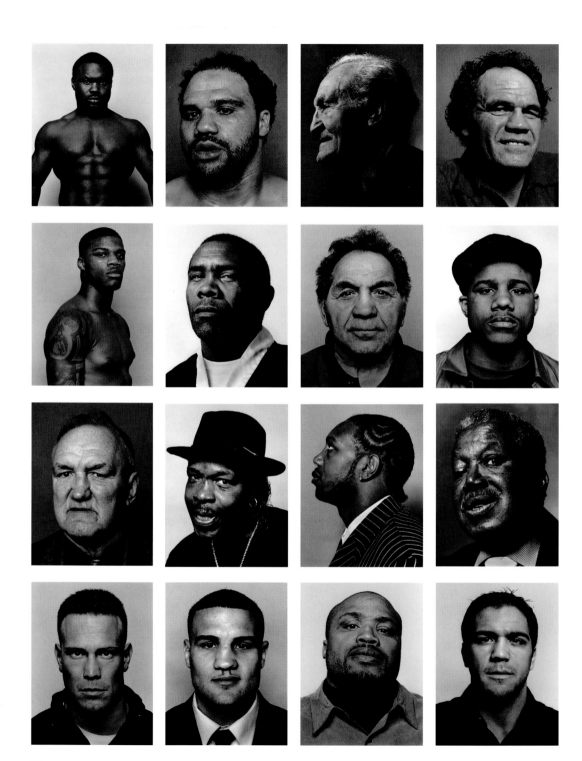

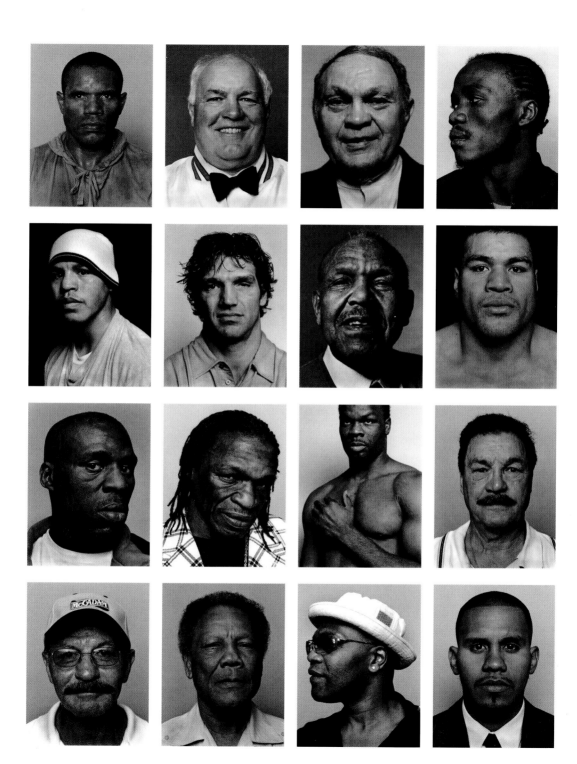

"I feel like I've been successful in boxing. I didn't achieve the status of a Mike Tyson or a Lennox Lewis, but I'm happy with what I achieved. Coming from where I came from, homeless in Brooklyn, sleeping in shelters, everything I did was an accomplishment.

I DON'T CARE WHAT ANYONE ELSE SAYS; I MADE GOOD.

I'm proud of what I've accomplished. And I was the lineal heavyweight champion of the world whether people like it or not."

SHANNON BRIGGS

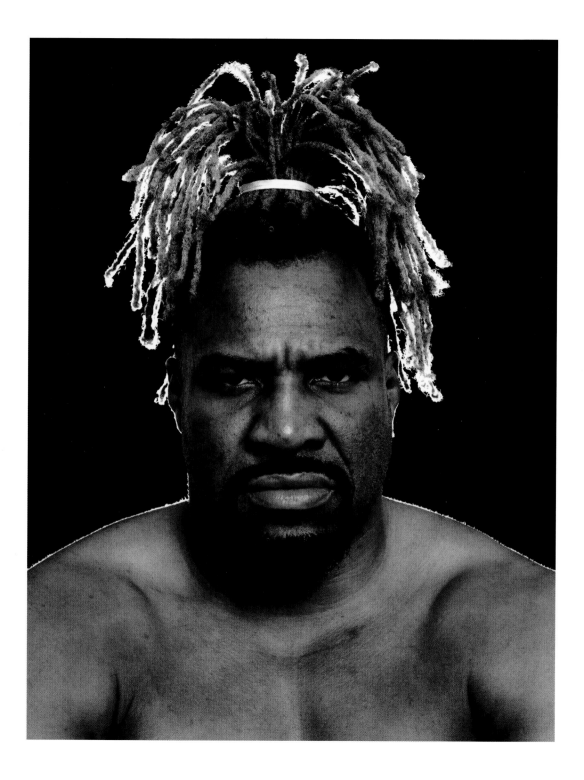

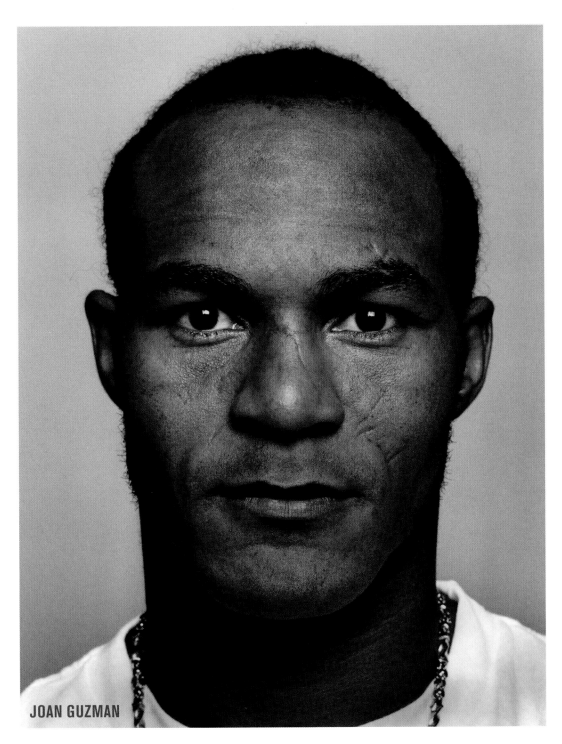

JOAN GUZMAN

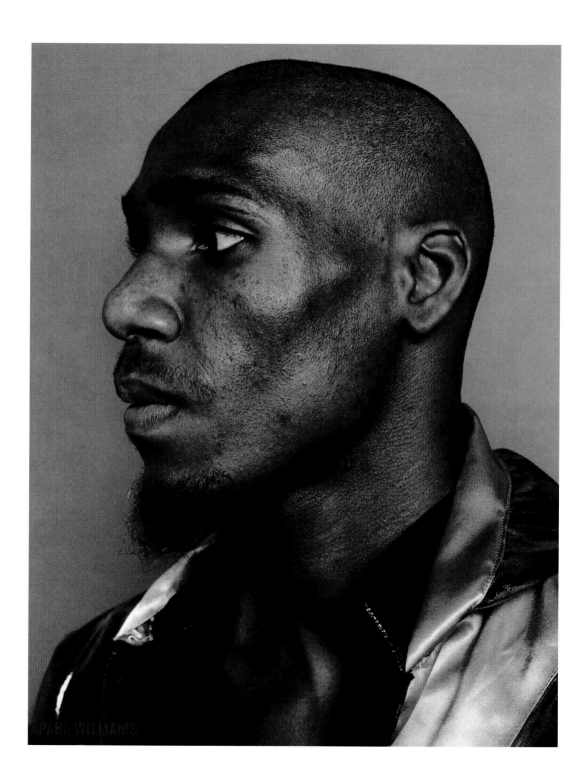

"Boxing saved my life. All of my identity and self-worth come from boxing. Boxing gave me everything I have, including my self-esteem.

WITHOUT BOXING, I'D BE NOTHING."

PAULIE MALIGNAGGI

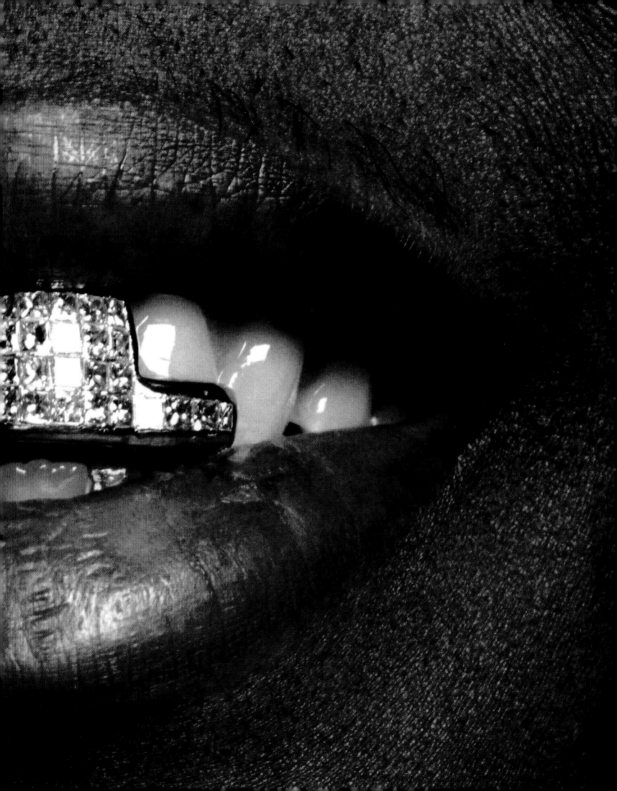

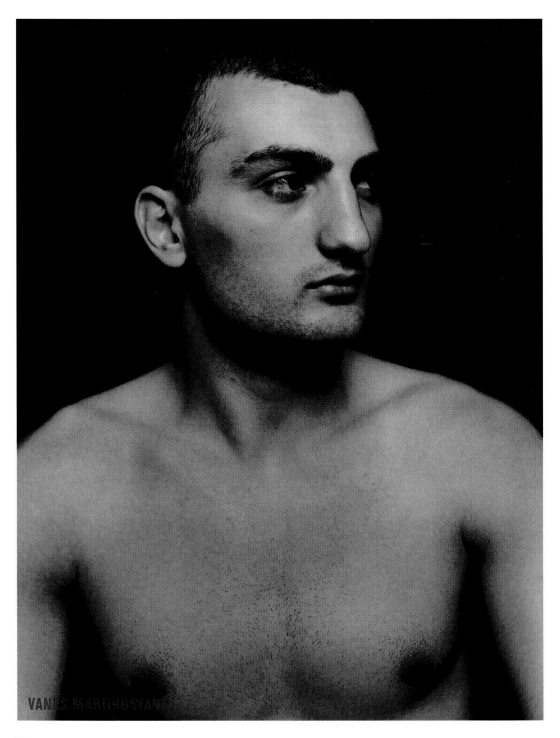

VANES MARTIROSYAN

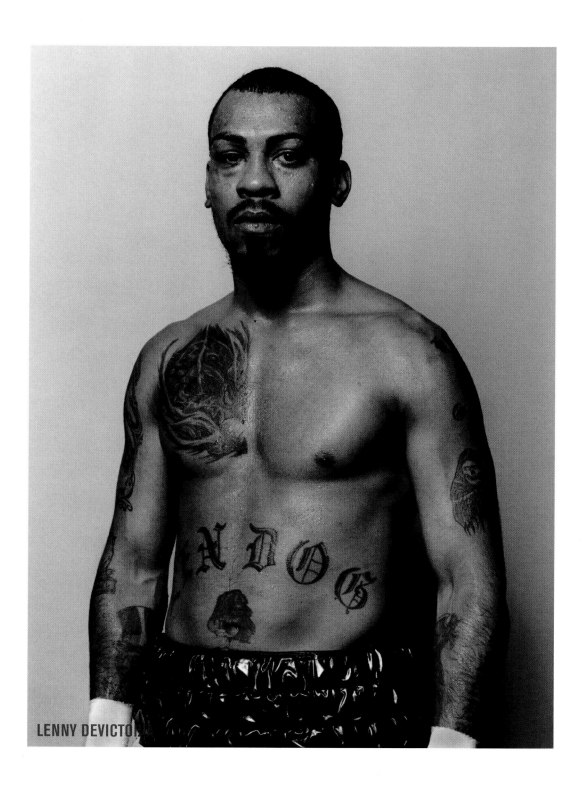

LENNY DEVICTO

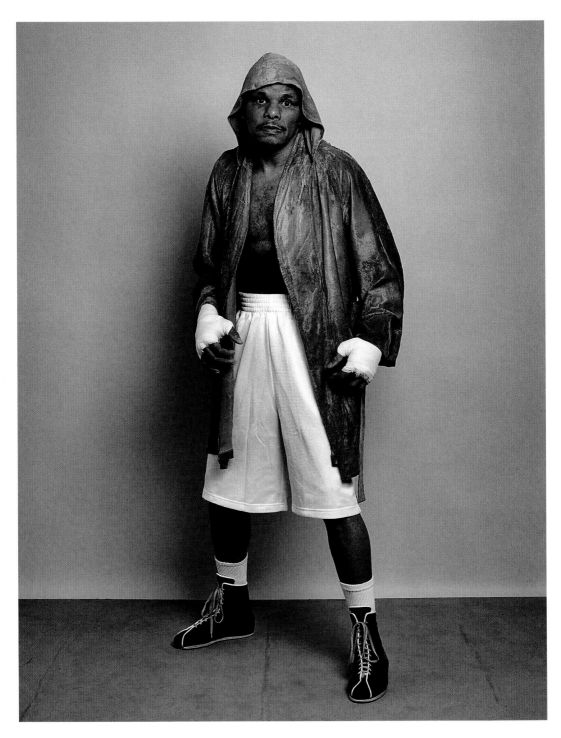

"Putting guys in body bags in Vietnam, knowing that all their dreams had died with them; I vowed that, if I got out of there alive, I was going to do what I wanted to do with my life.

BOXING MAKES ME FEEL HAPPY AND COMPLETE;

so I'm boxing. I risked my life in Vietnam, and I can do what I want with it now."

SAOUL MAMBY

Overleaf, left to right; Yuri Foreman, Fres Oquendo, William Joppy, Juan Laporte, Hasim Rahman, Ricardo Mayorga, Terry Norris, John Ruiz, James Smith

UT IN A BOXING RING.

"I've seen a lot of guys who are tough on the streets come into the gym and turn their back once they get in the ring. Boxing does one of two things. It makes a coward out of you or it makes you a man."

PAULIE MALIGNAGGI

Overleaf, left to right; Eddie Mustafa Muhammad, Wayne McCullough, Kennedy McKinney, Buddy McGirt, Sergei Liakhovich, Raul Marquez, Carlos Quintana, Dwight Muhammad Qawi, Samuel Peter

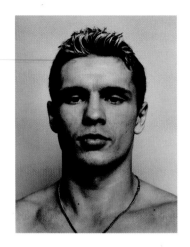
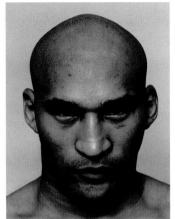
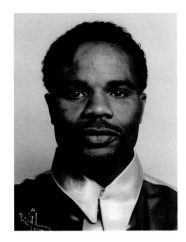
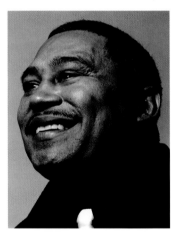
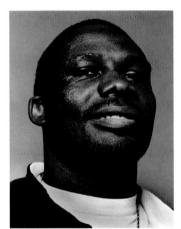
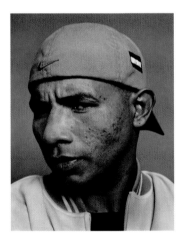
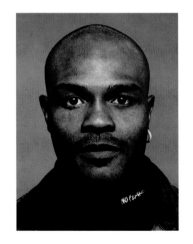
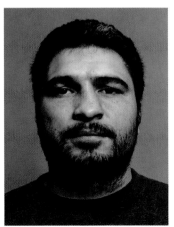
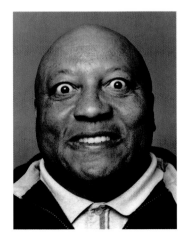

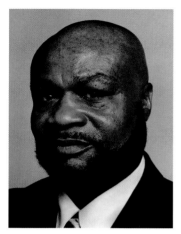 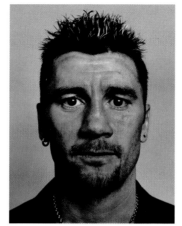 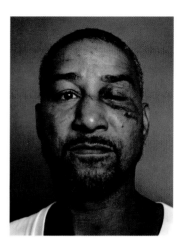

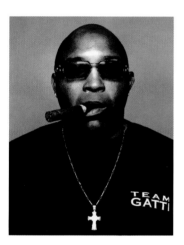 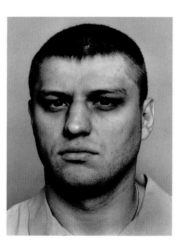 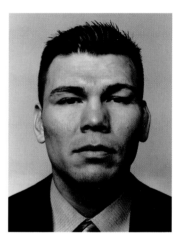

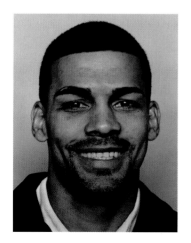 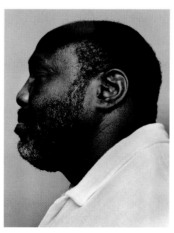 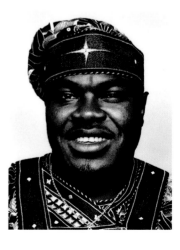

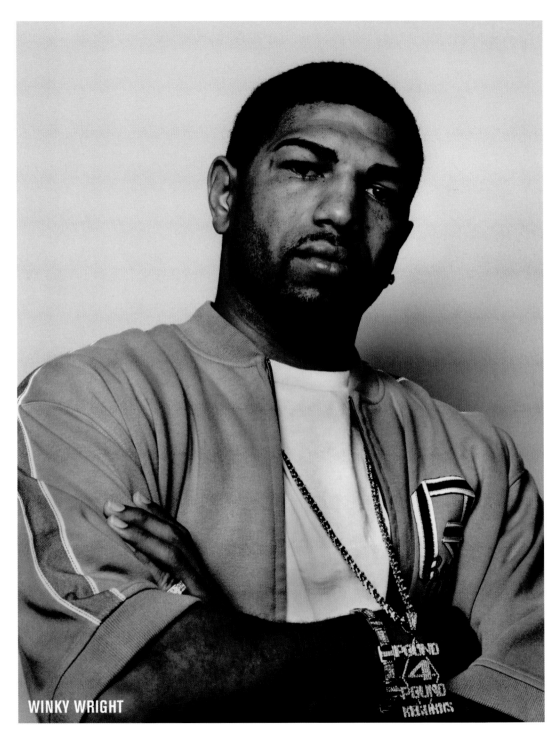

WINKY WRIGHT

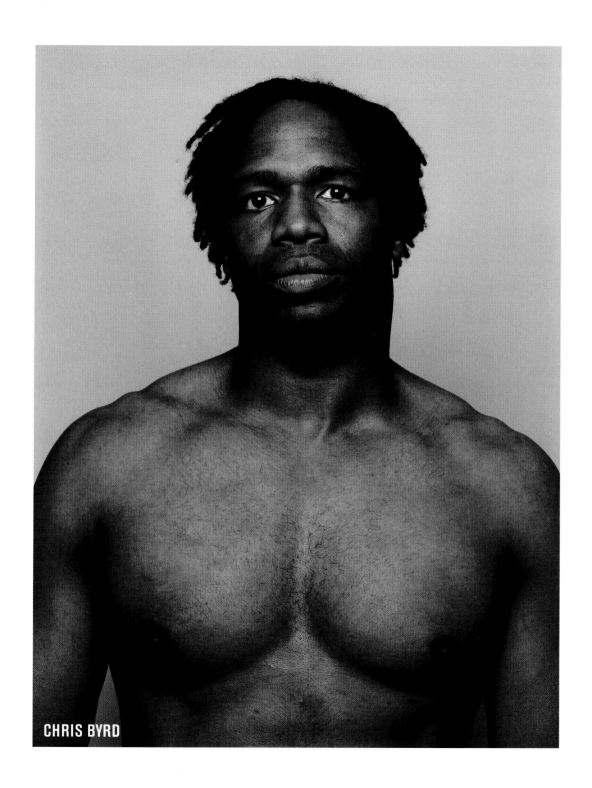

CHRIS BYRD

[on his 1982 fight in which Duk-Koo Kim was killed]:
"That fight took my heart away from the game. I kept
saying to myself,

'WHY HIM AND NOT ME?'

And who was to say it wouldn't be me the next time?
I was looking to get out."

RAY MANCINI

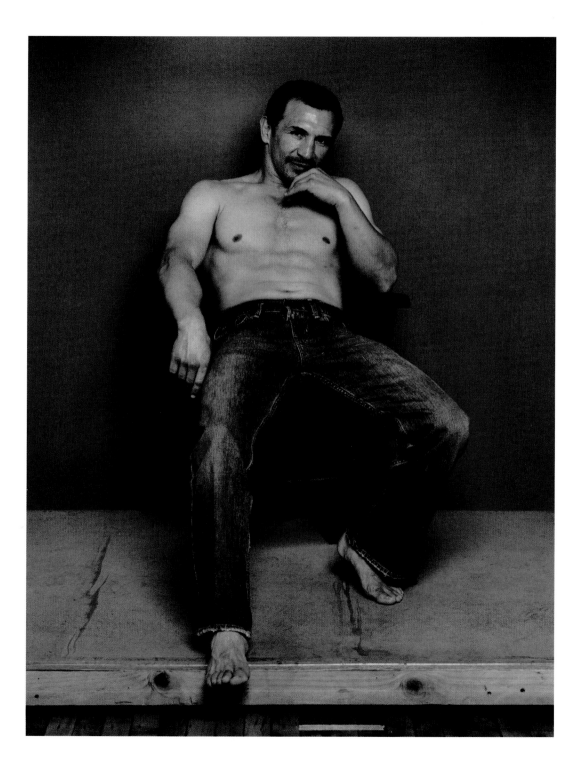

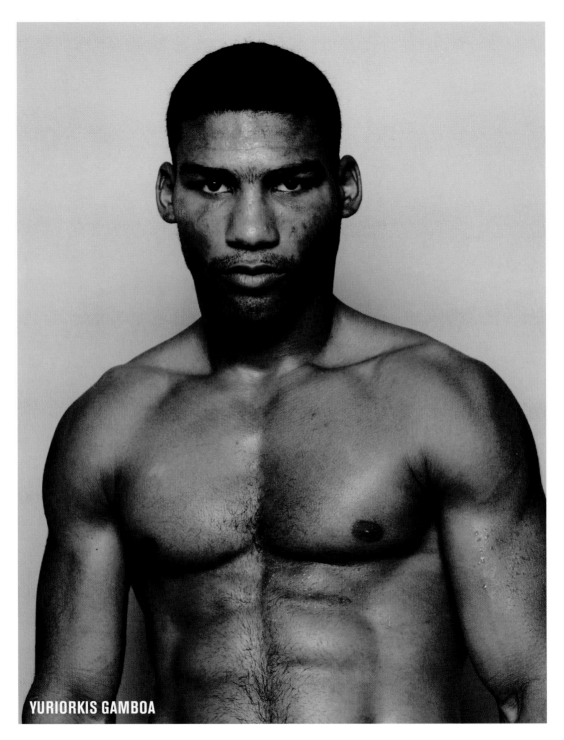

YURIORKIS GAMBOA

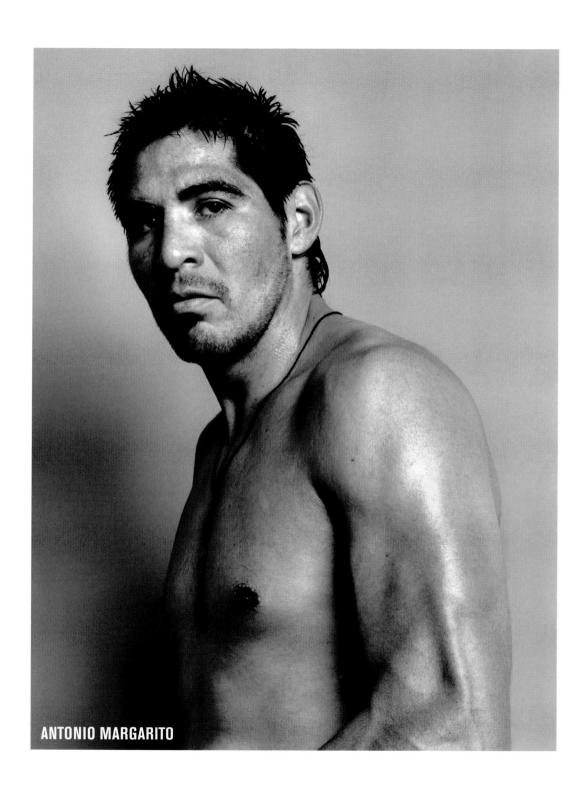

ANTONIO MARGARITO

"Sometimes I think about how my life changed, being champion. It wasn't right, the way people treated me. I was fighting to get ahead. All I wanted was to make a living. And

THE WORLD WANTED ME TO BE LIKE ALI."

LEON SPINKS

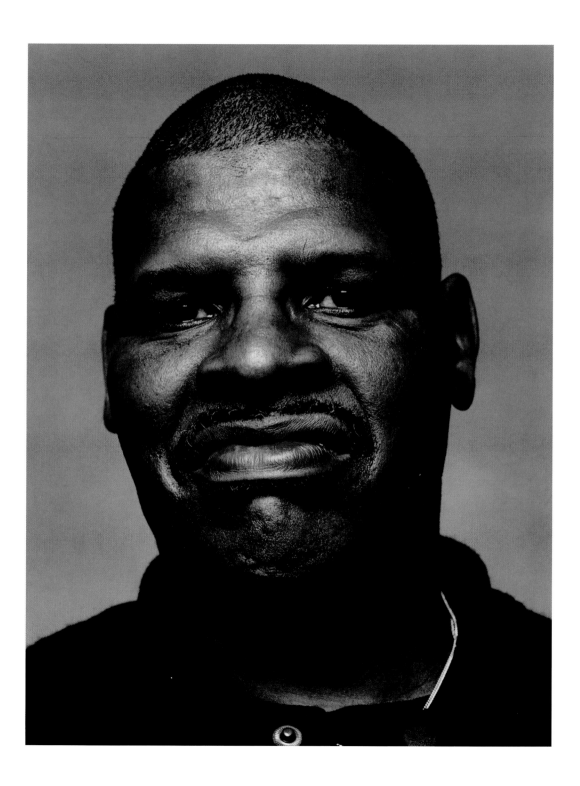

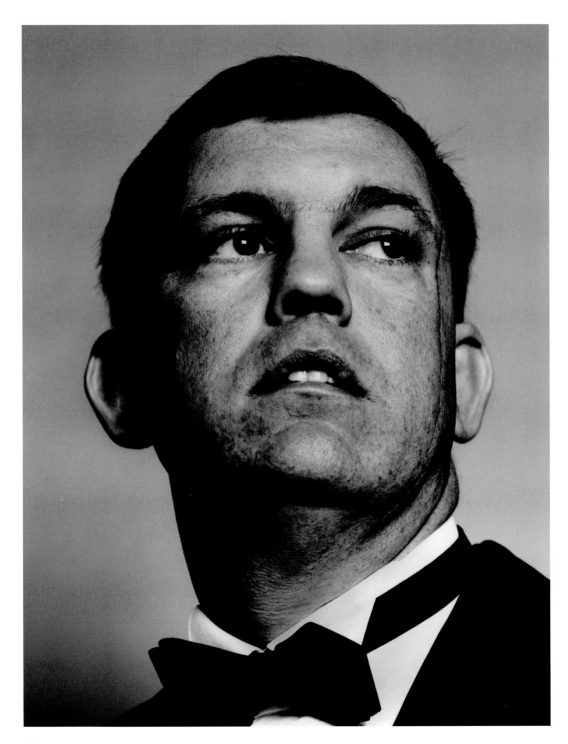

"YOU CAN TEACH A FIGHTER ALL THE MECHANICS IN THE WORLD AND HE STILL MIGHT NOT KNOW HOW TO EMPLOY THEM.

The mental toughness, the psychological things you teach a fighter, are just as important as teaching him technique."

TEDDY ATLAS

[on his 1962 fight in which Benny "Kid" Paret was killed]:
"I was never the same fighter after that. After that fight,
I did enough to win. I would use my jab all the time. I never
wanted to hurt the other guy. I would have quit, but

I DIDN'T KNOW HOW TO DO ANYTHING ELSE BUT FIGHT."

EMILE GRIFFITH

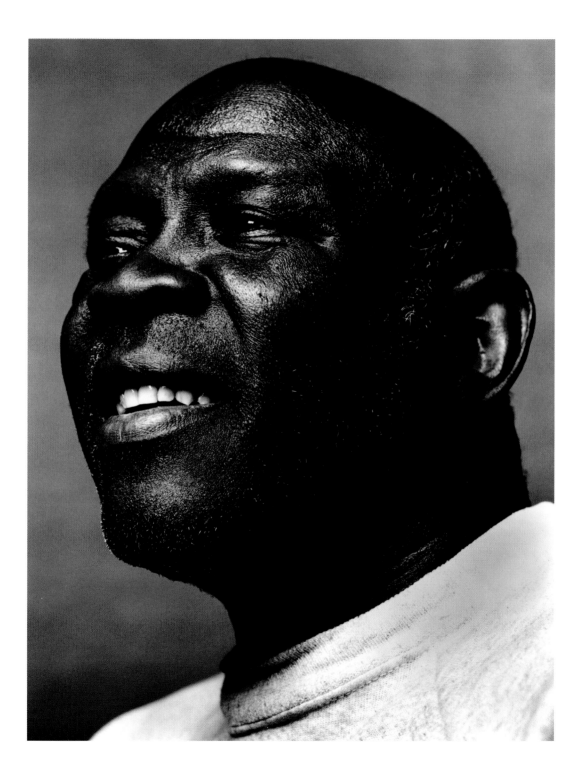

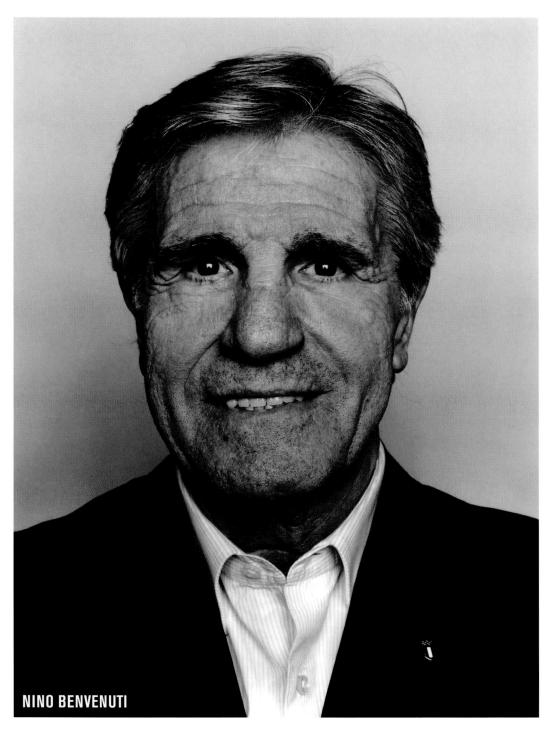

NINO BENVENUTI

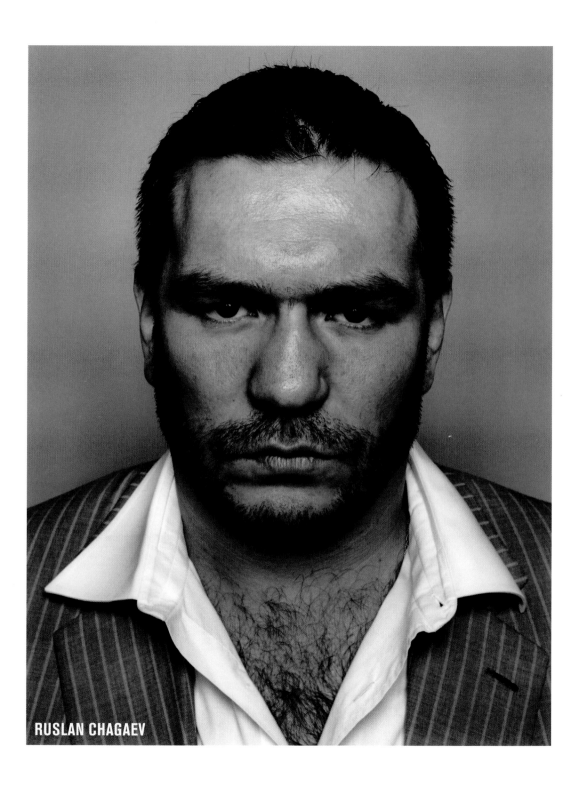

RUSLAN CHAGAEV

(on fighting Muhammad Ali):

"HE WAS JUST SO DAMNED FAST."

GEORGE CHUVALO

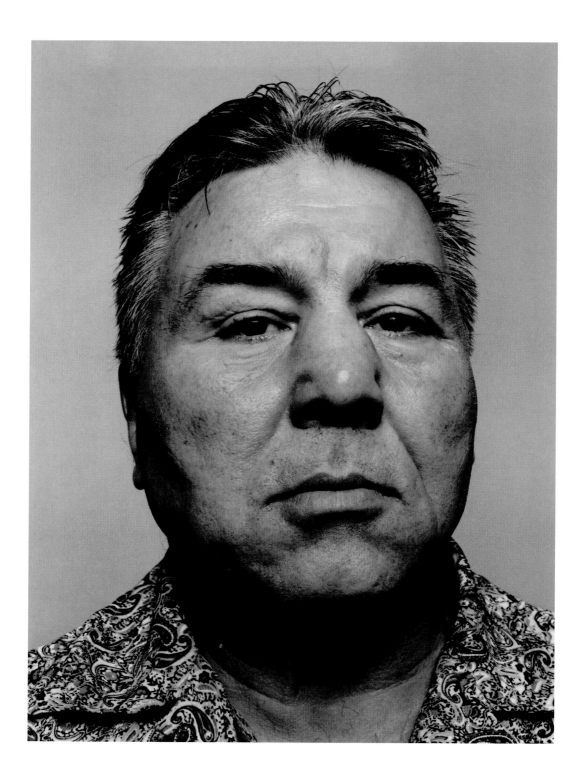

"Boxing is a great sport. It's not easy; that's for sure.

THERE'S NOTHING EASY ABOUT BOXING.

There's plenty of heartache. A lot of tears have been
shed in this business. But I'm proud to have been part
of boxing history."

BOUIE FISHER

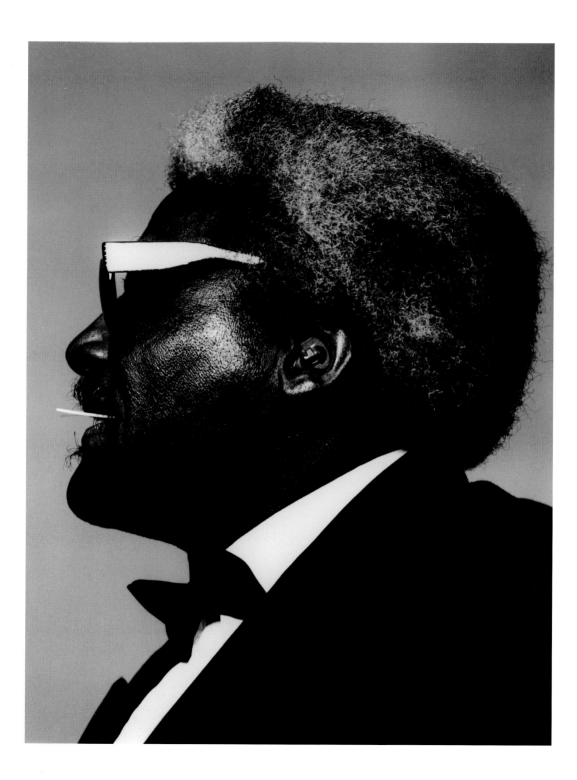

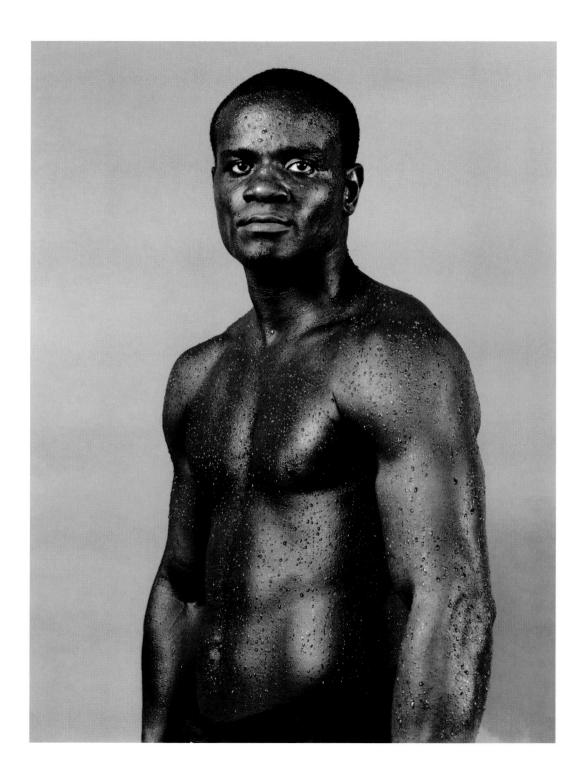

"People like to imagine boxers as self-sustaining warriors. And we're not. I've been around former world champions who are ashamed. They have nothing to show for their careers, nowhere to go, and no one to help them when the roar of the crowd is gone. I was one of the lucky ones. I made good money and put some of it aside. But even

I DIDN'T KNOW WHAT TO DO AFTER BOXING."

GERRY COONEY

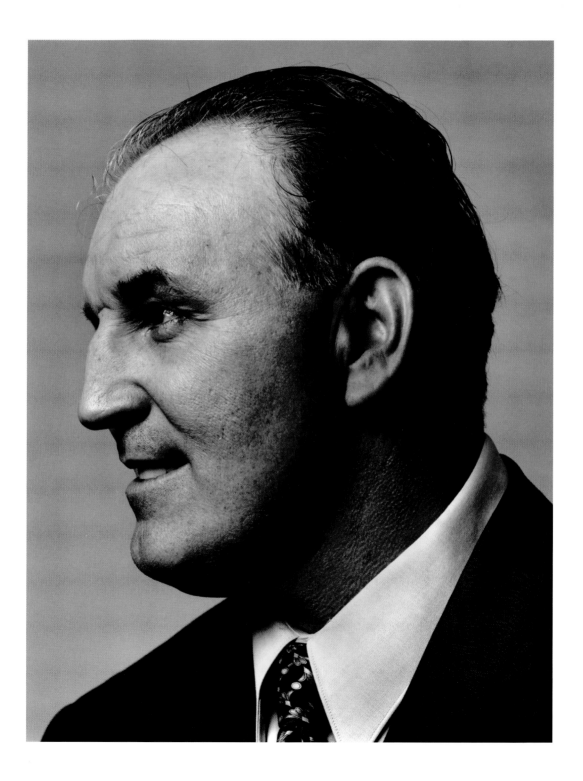

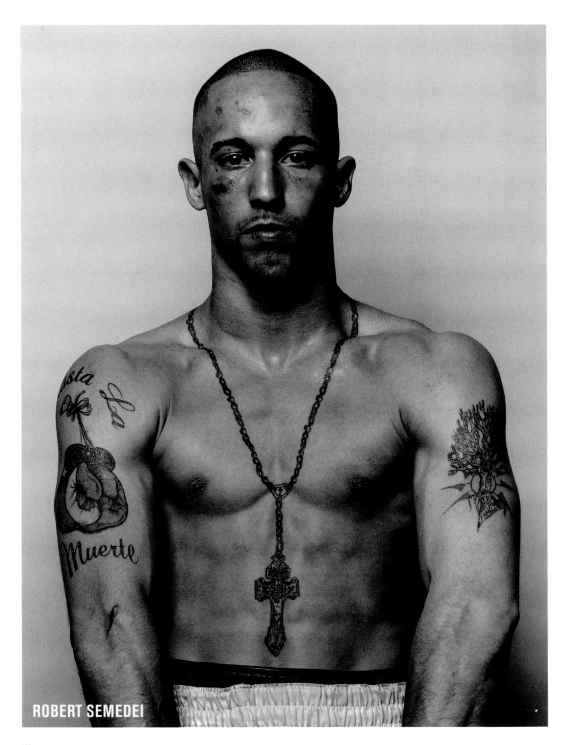

ROBERT SEMEDEI

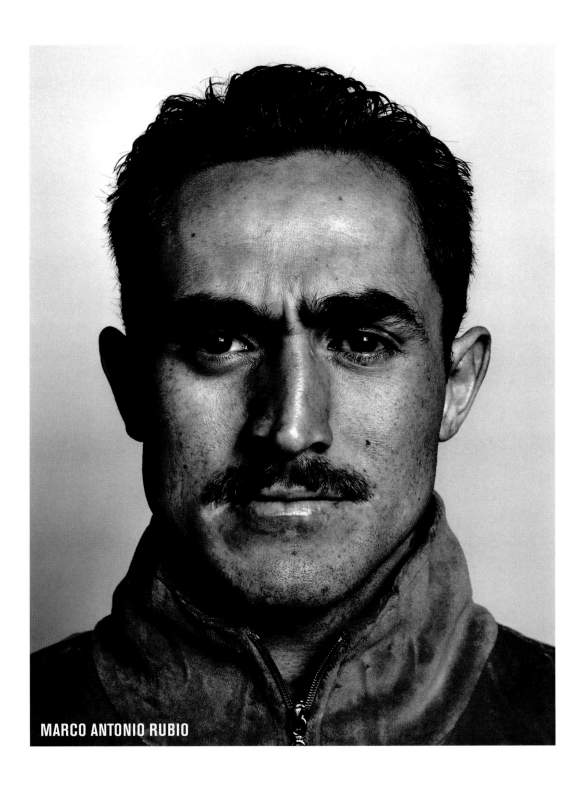
MARCO ANTONIO RUBIO

"IT'S TWO GUYS IN THE RING WHO HARDLY KNOW EACH OTHER, BEATING THE CRAP OUT OF EACH OTHER.

The crowd oohs and aahs, and I want to get my oohs and aahs in. Then it's over, and you shake hands and hug each other. Go figure."

CHRIS ARREOLA

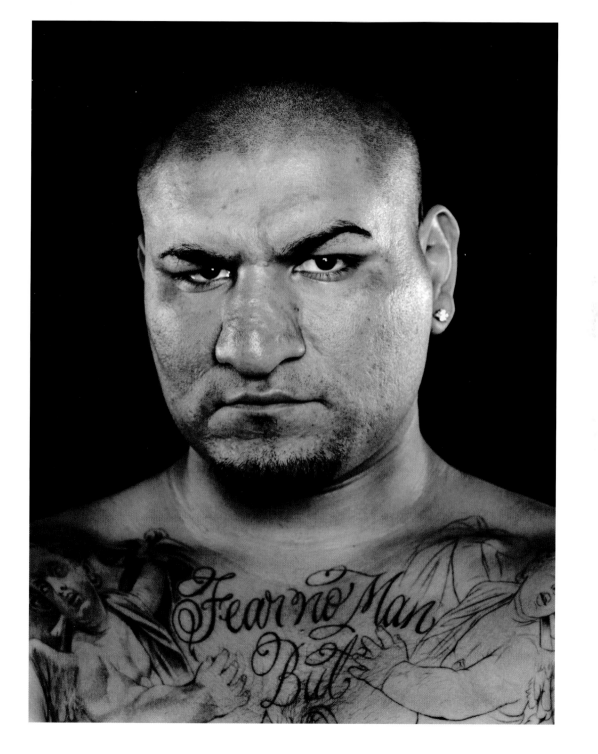

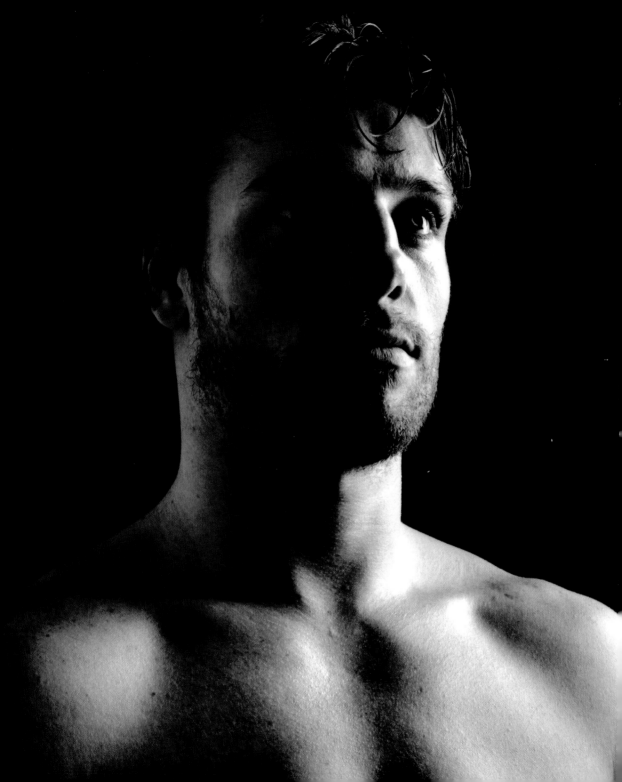

"I'M HAPPY. I'M LIVING MY DREAM.

Boxing has taken me a long way. It's a tough job, but it's a good job. And I'm very lucky; I'm from Ireland. That means, wherever I go, I have Irish people offering to help and cheering for me."

JOHN DUDDY

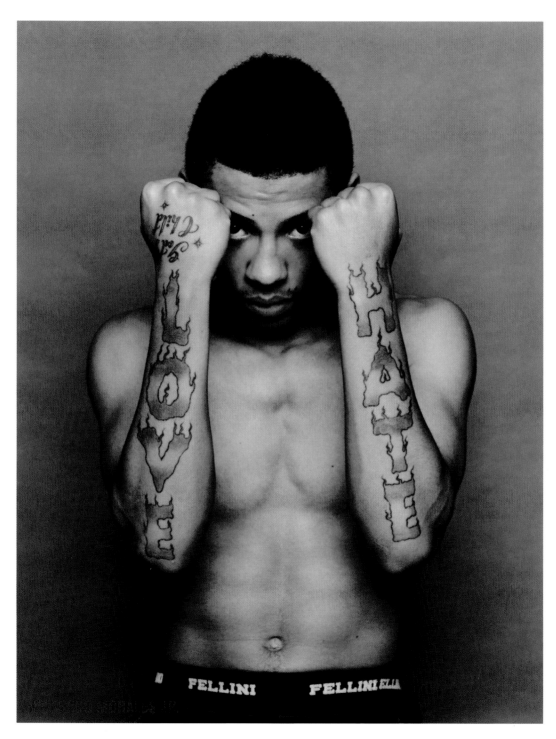

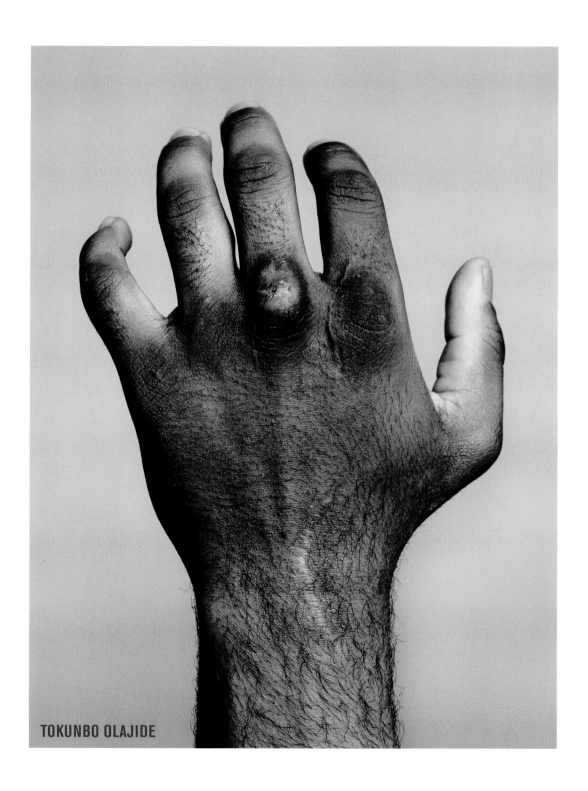

TOKUNBO OLAJIDE

"I was sparring at Gleason's Gym and got hit with an uppercut that damaged the orbital socket, the bone the eye sits on. That started it. Then I was sparring with Merqui Sosa and got thumbed in the eye and needed surgery. After that, I fought Tommy Hearns and suffered a vitreous hemorrhage. I can see shadows now and that's all.

I'M LEGALLY BLIND IN MY RIGHT EYE."

MICHAEL OLAJIDE

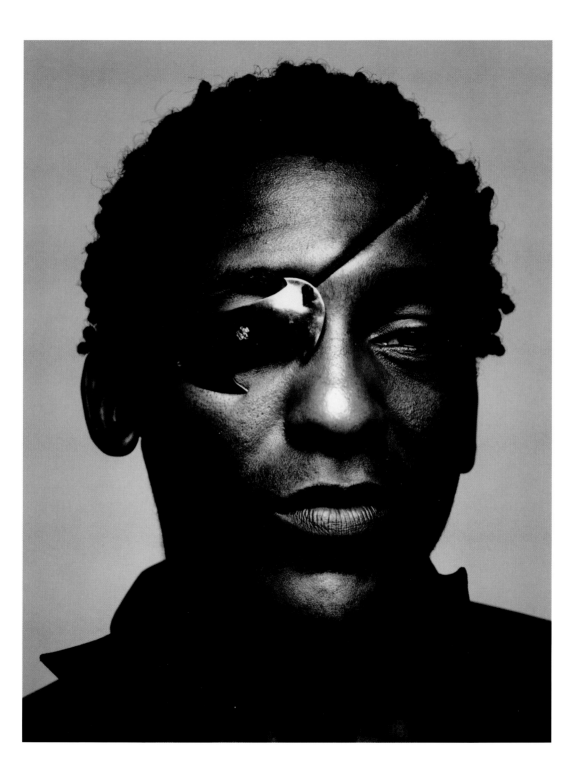

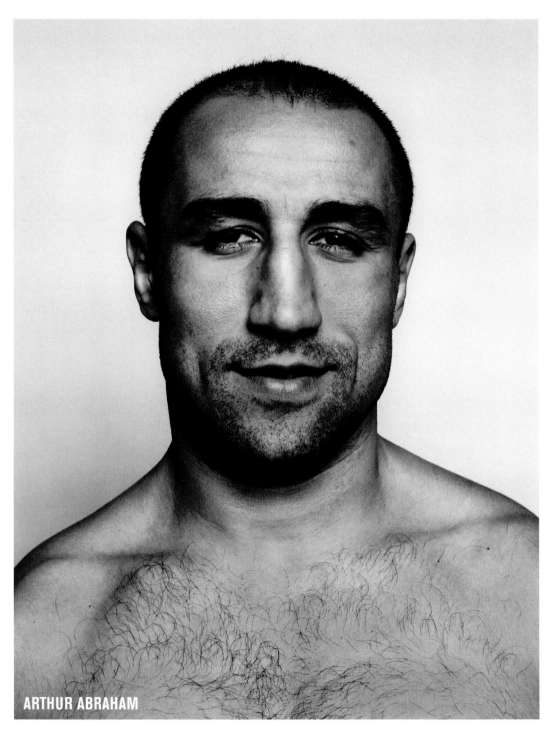

ARTHUR ABRAHAM

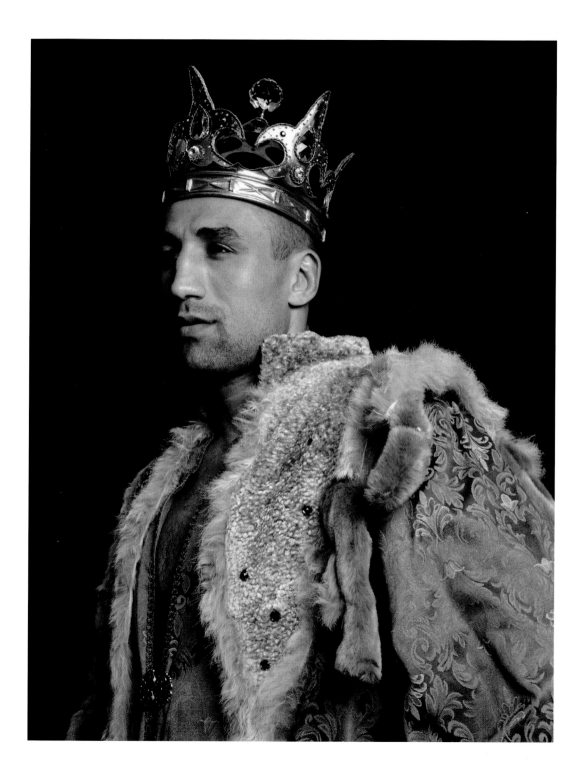

"THINGS HAPPEN INCREDIBLY FAST IN A BOXING RING. AND SOMETIMES WHEN THEY DO, YOU'RE POWERLESS TO DO ANYTHING BUT COUNT."

ARTHUR MERCANTE SR.

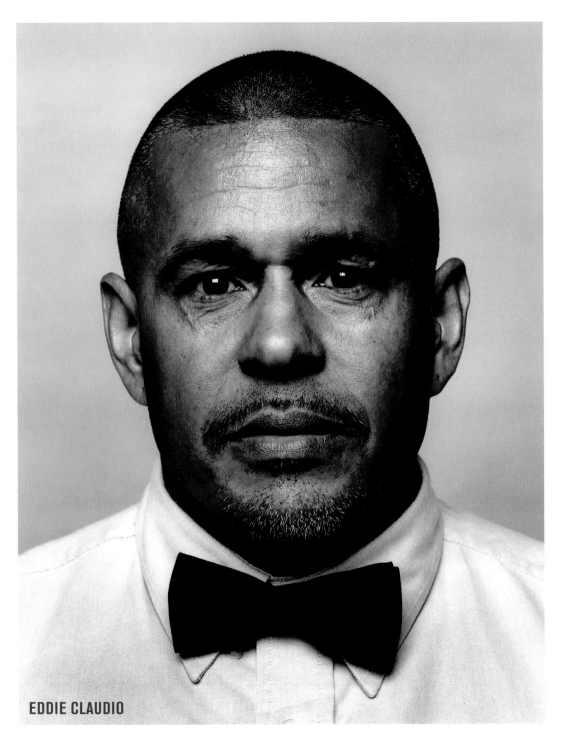

EDDIE CLAUDIO

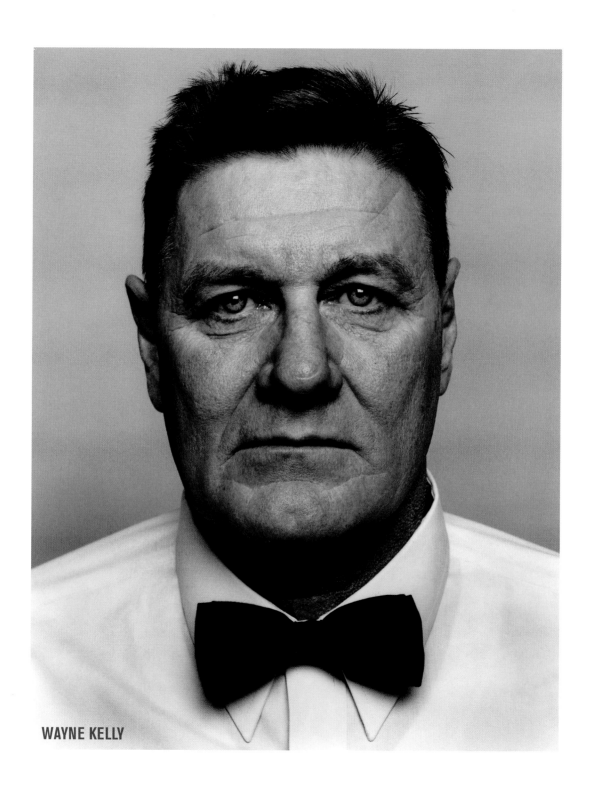

WAYNE KELLY

"I know the streets. But I know the boundaries of life too. Don't be out there selling drugs because, sooner or later, you're gonna get locked up. Don't get in a fight that will land you in trouble.

WITH EVERY OPTION, THERE'S A REPERCUSSION; SO THINK BEFORE YOU MAKE A MOVE."

CURTIS STEVENS

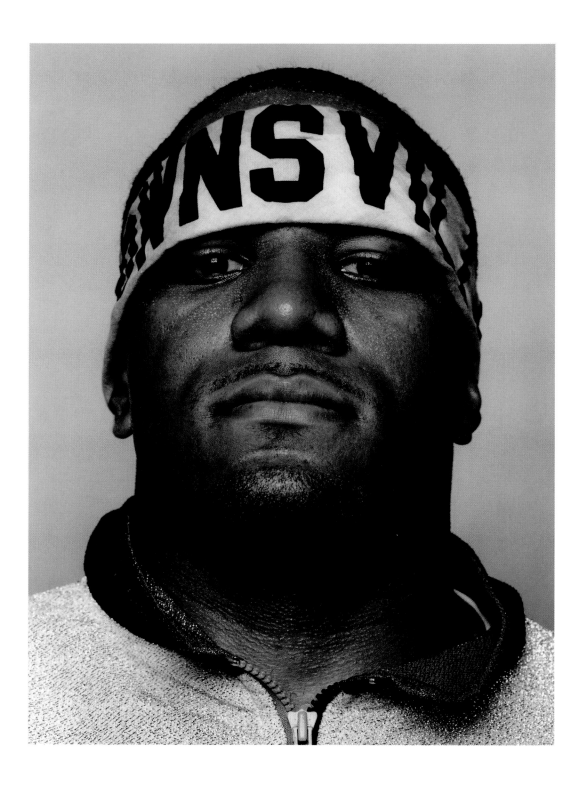

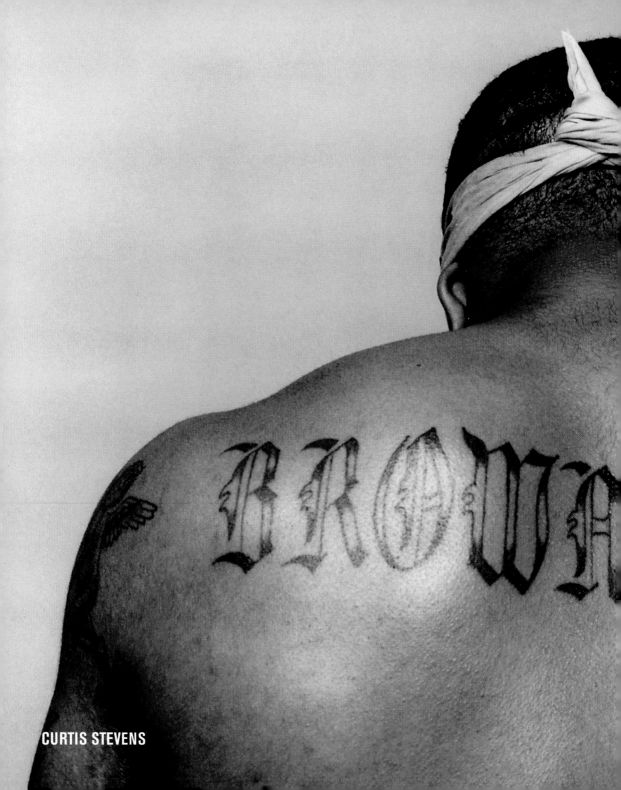

CURTIS STEVENS

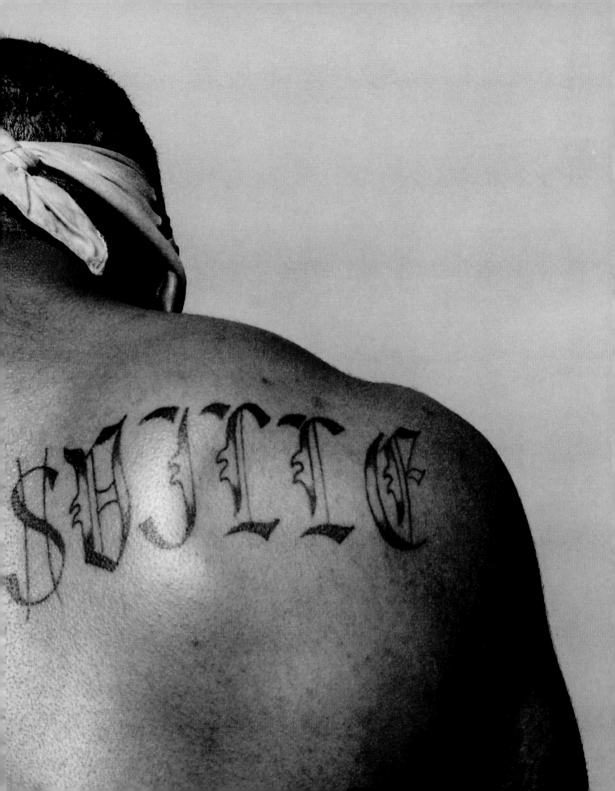

"Larry Holmes lost to Michael Spinks and left the ring before he was interviewed. Ross [HBO executive producer Ross Greenburg] was screaming, 'Somebody fucking get Larry Holmes; he's leaving the ring.' So I ran to the locker room, got there before Larry, and picked up a headset. Larry came in. Someone closed the door behind him and said no interviews.

LARRY WAS CRYING. HIS FAMILY WAS CRYING. I FELT SO BAD FOR THEM THAT I STARTED CRYING TOO.

Larry looked at me and said, 'Tami, don't cry, honey. Tell HBO I'll give them an interview.'"

TAMI COTEL

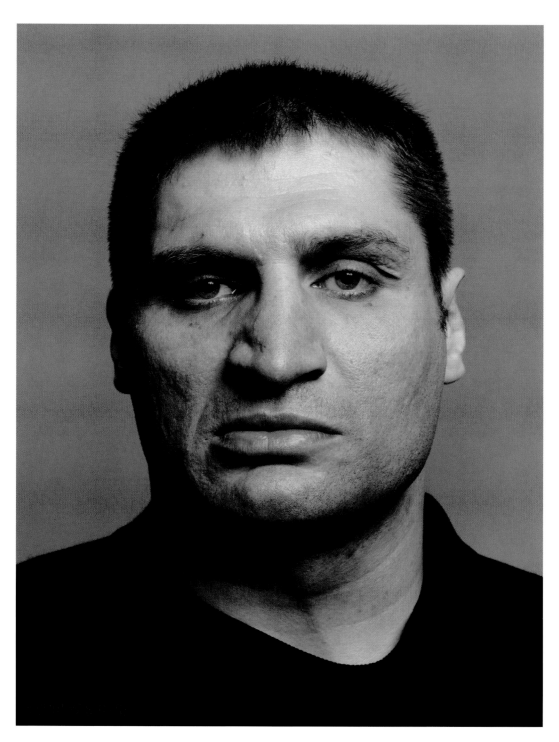

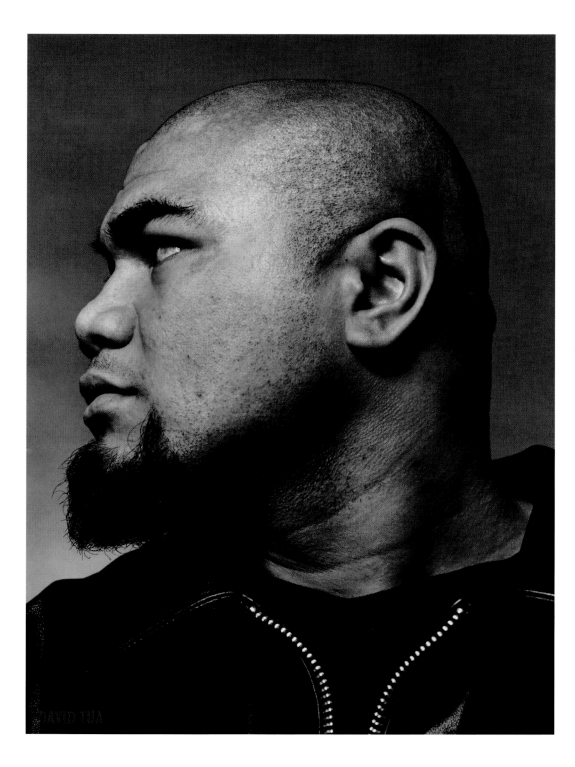
DAVID TUA

"THINGS ARE EASIL CORNER THAN DON

Overleaf, left to right; Freddie Roach, Emanuel Steward, Donald Turner, Stacey McKinley, Javier Capetillo, Miguel Diaz, Tommy Gallagher, Pat Burns, Jimmy Glenn

R SAID FROM THE
E IN THE RING."

Overleaf, left to right; Kevin Rooney, Fritz Sdunek, Lou Duva, Al Gavin, Gil Clancy, Bob Jackson, Macka Foley, Hector Rocca, Joel Judah

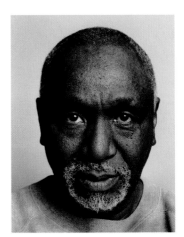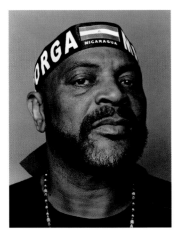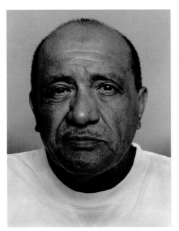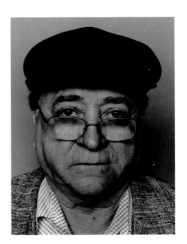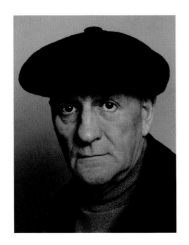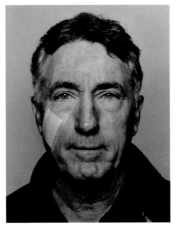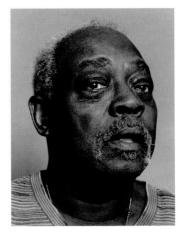

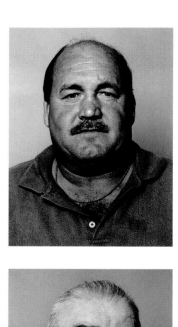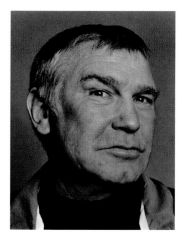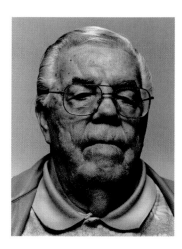
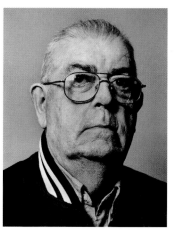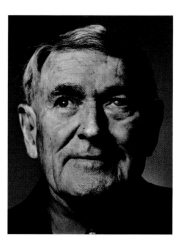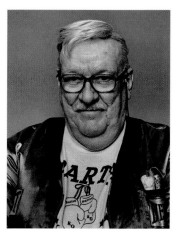
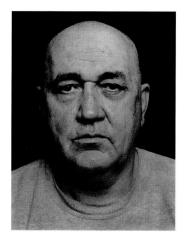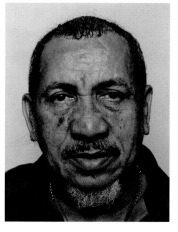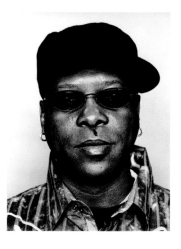

"I was a bucket carrier who hung around the gym and listened and watched.

I KEPT MY EYES AND EARS OPEN AND MY MOUTH SHUT.

That's how I learned from some of the greatest trainers who ever lived. Ray Arcel, Charlie Goldman, Whitey Bimstein; those guys gave of themselves. Chickie Ferrera taught me how to tie a fighter's shoes."

ANGELO DUNDEE

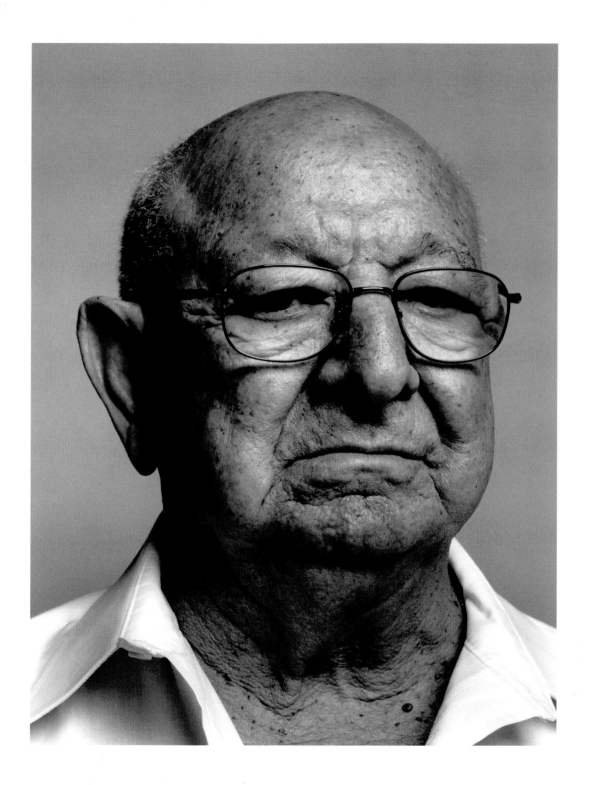

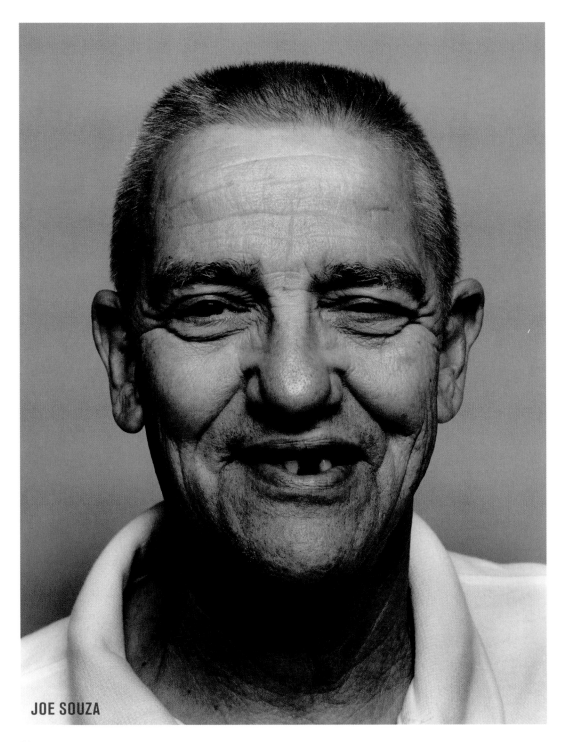

JOE SOUZA

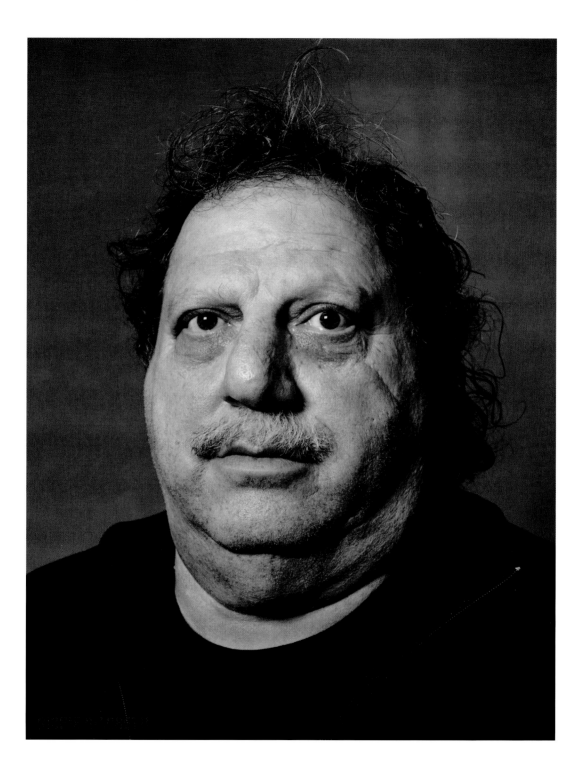

"THERE ARE NO PER
IN BOXING, AND TH
PERMANENT ENEM

MANENT FRIENDS ERE ARE NO IES IN BOXING."

MICKEY DUFF

Overleaf, left to right; Dino Duva, Todd DuBoef, Butch Lewis, Bobby Goodman, Judd Burstein, Tony Cardinale, Pat English, Ron Katz, Shelly Finkel, Ivaylo Gotzev, Stan Hoffman, Carl King, Roger Levitt, Sal LoNano, Pat Lynch, Sam Simon

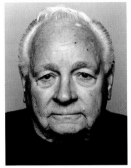
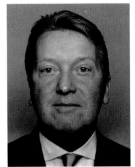
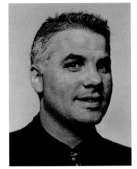
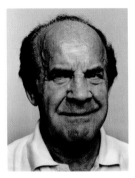
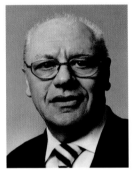
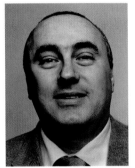
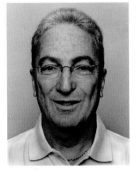
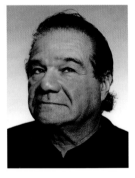
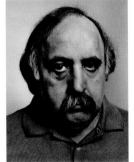
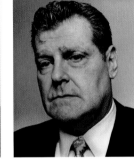
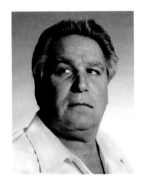
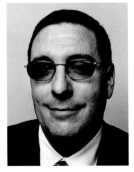
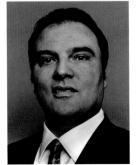
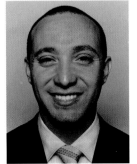
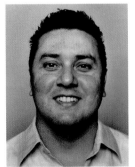

"We build fighters at Top Rank; step by step so, by the time they fight for a title, the fans know who they are and they're ready to win. The process moves slowly and can be frustrating for the fighters. But

IF A FIGHTER IS PATIENT AND DOES HIS JOB IN THE RING, THAT PATIENCE PAYS OFF."

BOB ARUM

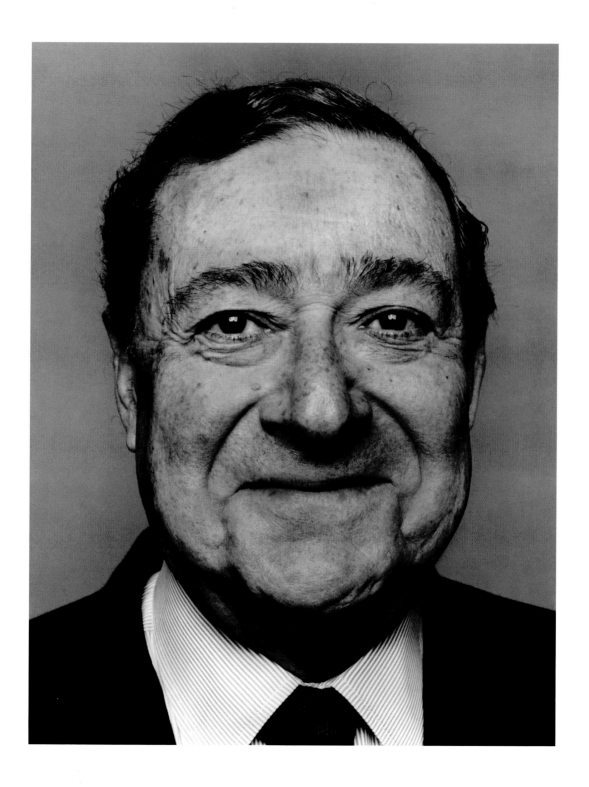

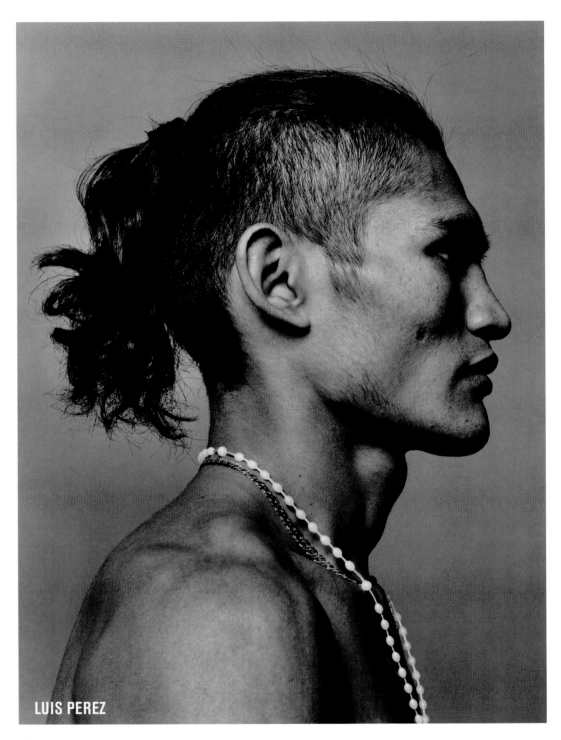

LUIS PEREZ

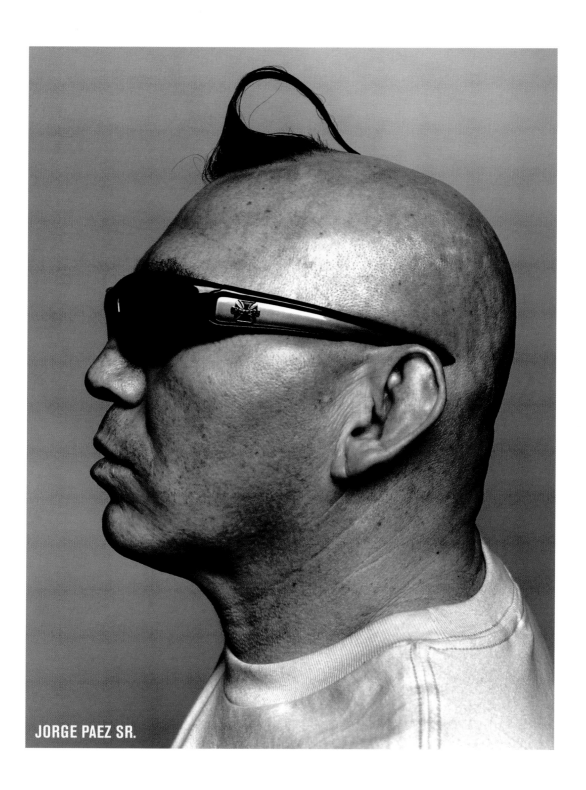

JORGE PAEZ SR.

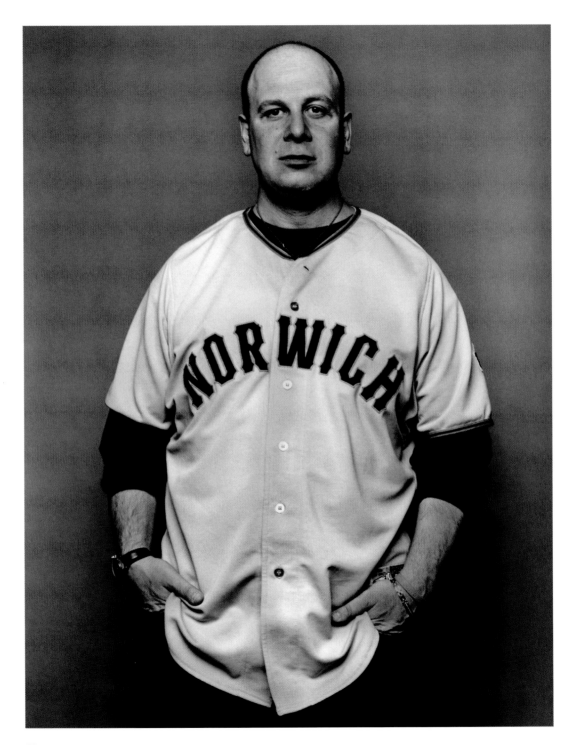

"BOXING IS A MISERABLE BUSINESS.

Everything is a deal. People lie all the time and don't even consider it lying. Sooner or later, virtually everyone adopts a go-along mentality or they get crushed.

LOU DIBELLA

LUIS COLLAZO

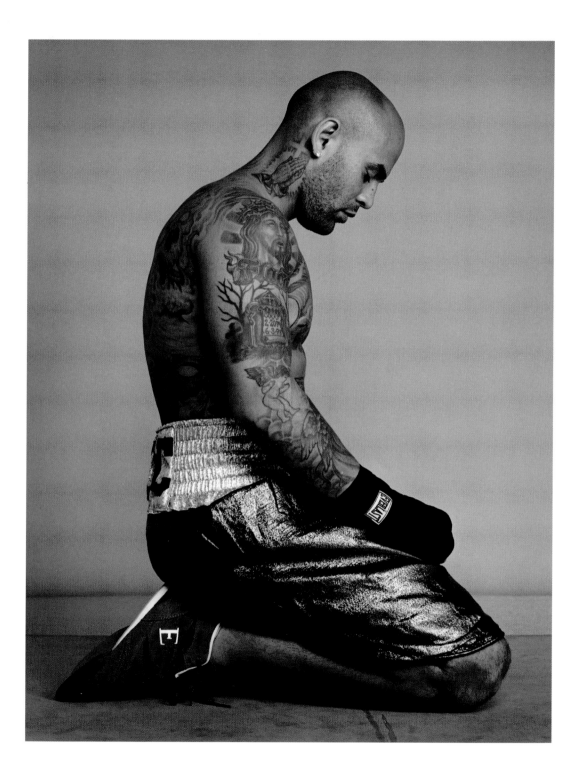

INDEX

Professional Groups

Page numbers in italics refer to illustrations.

FIGHTERS

ACKNOWLEDGMENTS

I would like to thank everybody who participated in this project for their time and generosity of spirit. My eight-year-long voyage into the world of boxing has been an exhilarating, exciting, and enriching experience. Special thanks to Coco Cocoves, Lou DiBella, Joe Dwyer, Doug Fischer, Bobby Goodman, Tom Hoover, Alan Hopper, Ricardo Jimenez, Gene Kilroy, Cedric Kushner, Steve Lott, Heiko Mallwitz, Tony Mazzarella, Freddie Roach, Lee Samuels, Monica Sears, Bruce Silverglade, and Ben Wett for their support.

A special appreciation to Frank Otten and to Debbie Ullman for her invaluable input and help.

Holger Keifel

My thanks, also, to the following people, who've made my journey through the sweet science over the past quarter century a joyful one: Seth Abraham, Steve Albert, Bob Arum, Teddy Atlas, Al Bernstein, Michael Buffer, Pat Burns, Bob Canobbio, Anthony Catanzaro, Tami Cotel, David Diamante, Todd DuBoef, Bob Duffy, Don Elbaum, Pat English, Anthony Evans, Steve Farhood, Bouie Fisher, Joel Fisher, Tom Gerbasi, Jimmy Glenn, Margaret Goodman, Meredith Greenberg, Craig Hamilton, Flip Homansky, Jerry Izenberg, Ron Katz, George Kimball, Don King, Jim Lampley, Jay Larkin, Harold Lederman, Jimmy Lennon, Pat Lynch, Mike Marchionte, Larry Merchant, Alton Merkerson, Danny Milano, Bobby Miles, Carl Moretti, Sal Musumeci, LeRoy Neiman, Randy Neumann, Joe Quiambao, Naazim Richardson, Ron Rizzo, Chris Santos, Lem Satterfield, Richard Schaefer, Bob Sheridan, Sam Simon, Tim Smith, Ray Stallone, Fred Sternburg, Ron Scott Stevens, Emanuel Steward, Mark Taffet, Jim Thomas, Bruce Trampler, Donald Turner, Paul Upham, Frank Warren, and Robert Waterman.

And to the fighters; all of them, too numerous to mention. Thank you.

Thomas Hauser

First published in the United States in 2010 by Chronicle Books LLC.

Concept and design © 2010 by PQ Blackwell Limited
Images copyright © 2010 Holger Keifel
Text copyright © 2010 Thomas Hauser
All rights reserved. No part of this book may be reproduced
in any form without written permission from the publisher.

Library of Congress Cataloging-in-Publication Data available.

ISBN: 978-0-473-16416-4

Manufactured in China

Produced and originated by PQ Blackwell Limited
116 Symonds Street, Auckland, New Zealand
www.pqblackwell.com

Book design by Cameron Gibb

10 9 8 7 6 5 4 3 2 1

Chronicle Books LLC
680 Second Street
San Francisco, CA 94107

www.chroniclebooks.com